Soul-Wrestling

Other Books of Interest from St. Augustine's Press

SOUL-WRESTLING

MEDITATIONS IN MONOCHROME

KEN BAZYN

ST. AUGUSTINE'S PRESS
SOUTH BEND, INDIANA

Manufactured in the United States of America

1 2 3 4 5 6 22 21 20 19 18 17 16

Library of Congress Cataloging in Publication Data
Bazyn, Ken.
Soul-wrestling: meditations in monochrome / Ken Bazyn. — 1st edition.
pages cm
ISBN 978-1-58731-769-9 (hardback)
1. Devotional literature. I. Title.
BV4832.3.B39 2014
242–dc23 2014038882

∞ The paper used in this publication meets the minimum requirements of the American National Standard for Information Sciences Permanence of Paper for Printed Materials, ANSI Z39.481984.

ST. AUGUSTINE'S PRESS
www.staugustine.net

Contents

CONTENTS

Introduction

Swiss philosopher Denis de Rougemont once called art a "trap for meditation."[1] By coupling the visual with the verbal, I've tried to create photo meditations, whereby one art form enhances and embraces the other. Vision is considered the sense par excellence,[2] yet studies indicate that if we stimulate one sense, the others also become more alert.[3] "Synesthesia" is the scientific term which designates the way one sense can evoke another.[4] Think of the associations vowel sounds had for the French poet Rimbaud (e.g., "A, black velvety jacket of brilliant flies which buzz around cruel smells")[5] or Russian novelist Nabokov's depiction of "colored hearing" in his autobiography, *Speak, Memory* (e.g., "the long a of the English alphabet . . . has for me the tint of weathered wood").[6] The more senses entangled up with a memory, the more likely are we to make it our own.

I know I'm enamored of illustrated books, dramatizations of fiction, documentaries of historical figures, paintings of scenes from Scripture. If taken too literally, these visualizations can seem narrow or eccentric, but understood with a degree of latitude, they can set the mind spinning. Such are the workshop of Cranach's woodcuts for Luther's Bible; the decorated initials of the Lindisfarne Gospels; the rich store of early icons at St. Catherine's Monastery in Egypt; the Old and New Testament sculptures along the portals of Chartres Cathedral; the Good Shepherd mosaics in the churches of Ravenna; Giotto's frescoes of the life of Christ and of the Virgin Mary at the Arena Chapel in Padua. . . .

Around A.D. 600 Pope Gregory the Great admonished Bishop Serenus of Marseilles for banishing images from his diocese, pointing out that the use of paintings in churches enabled the illiterate to read upon the walls what they could not read in books.[7] A churchgoer, paying scant attention to the public readings of Scripture,

1 Quoted in chapter I, Roger Hazelton, *A Theological Approach to Art* (Abingdon, 1967), p. 21.

2 "Mind and Body," Diagram Group, *Man's Body: An Owner's Manual* (Bantam, 1979), p. E03.

3 R. W. Gerard, "The Biological Basis of Imagination," *The Creative Process*, edited by Brewster Ghiselin (New American Library, 1963), p. 240.

4 "Synesthesia," Diane Ackerman, *A Natural History of the Senses* (Random House, 1990), pp. 289–92.

5 "Vowels," *Rimbaud*, translated and edited by Oliver Bernard (Penguin, 1962), pp. 171–72.

6 Chapter 2, Vladimir Nabokov, *Speak, Memory* (Capricorn, 1970), pp. 34–36.

7 Chapter 1, Robin Margaret Jensen, *Face to Face: Portraits of the Divine in Early Christianity* (Fortress, 2005), p. 21. Cf. "Selected Epistles," book 9, letter 105, translated by James Barmby,

might be drawn like a moth to nearby pictures or sculptures, since the visual arts make splendid educational tools.[8] We human beings cannot help but think in images. "For whether I will or not," admitted Luther, "when I hear of Christ, an image of a man hanging on a cross takes form in my heart, just as the reflection of my face naturally appears in the water when I look into it."[9] What we read creates half-formed pictures in our minds and we are eager to fill in the details. Art can highlight and reinforce dramatic turning points in the story.

I am a picture-making animal. I reason from the concrete to the general, then back again. None of the photos in this book was manipulated in the darkroom. I didn't substitute a distracting background with one I felt brought out the main subject better, nor did I add some comely figure to the original or doctor an individual's expression or attire, just to suit my needs. I snapshot life as I found it. One possible etymology for the word "sincere" is from the Latin terms *sine* ("without") + *cera* ("wax"). Defective pottery could be filled with wax to make it appear more smooth, while "sincere" pottery was pure, unretouched, original.[10] In this sense my photos are "sincere."

I admire the technique of French photojournalist Henri Cartier-Bresson. When the light is right and some intriguing pattern or expression emerges, I'm anxious to capture that "decisive moment."[11] I rarely know ahead of time what subject will catch my fancy, nor am I one who rearranges backdrops in a studio. Thus critic Susan Sontag has compared photography to surrealism because of the way it welcomes the serendipitous: "What could be more surreal than an object which virtually produces itself, and with a minimum of effort?"[12] I become infatuated by a location which resonates with my unconscious, so I come back time and again, waiting for something to happen, or I set out at dusk when the sun casts its last gleams over the landscape, anxious to discover a dazzling vista. I want to thank with all my heart those who stopped long enough in their routines for this shutterbug to record an impromptu moment. A few I knew beforehand; others I just happened upon. I hope they'll pardon my invasion of their public space; what they were doing that day struck me as somehow universal.

Nicene and Post-Nicene Fathers, volume 13, edited by Philip Schaff and Henry Wace (Christian Literature Company, 1898), p. 267.

8 Chapter 3, Jaroslav Pelikan, *The Spirit of Eastern Christendom* (University of Chicago Press, 1977), p. 94.

9 "Against the Heavenly Prophets," part 1, translated by Bernard Erling, *Luther's Works*, volume 40, edited by Conrad Bergendoff (Muhlenberg Press, 1958), pp. 99–100.

10 "Sincere," Joseph T. Shipley, *Dictionary of Word Origins* (Littlefield, Adams & Co., 1967), p. 324.

11 "Cartier-Bresson, Henri," Cornell Capa, editorial director, *International Center of Photography Encyclopedia of Photography* (Pound Press, 1984), p. 100.

12 "Melancholy Objects," Susan Sontag, *On Photography* (Dell, 1979), p. 52.

I've deliberately chosen black-and-white for these meditations. Monochrome is out of sync with today's technicolor (video or digital) extravaganzas, thus my images will hopefully cause the reader to pause and reflect. By eliminating extraneous details, black-and-white can focus on shape and form, make facial expressions seem more dramatic, bring out the starkness of life itself (as in film noire). As in the ink landscapes of Zen masters, the tones of gray themselves are expansive as a full palette of colors.[13] Furthermore, there is more latitude in taking casual exposures; you're less likely to wash out bright spots or to overblacken dark ones. Since monochrome is less expensive to print, the price of this book will be lower.

Throughout I've mixed the abstract with the concrete, the pensive with the humorous, manikins with real people, flora with fauna, children with the aged, street scenes with pastorals, shadowy contrasts with high noon brightness. Each photo and meditation is meant to stand alone; there is no required sequence in reading; the topics are arranged alphabetically by title. Usually I've finished the devotion first, then searched for an appropriate photo. There is a suggested Scripture for each week of the year, a recommended hymn, a lead-in-quotation, provocative comments on the selected theme, and a closing prayer. These all work together to create an "ambience" that, as sociologist Robert Wuthnow says, promotes spirituality.[14] If I could sing or play a musical instrument with any dexterity, I would have included a CD as well. There is a loose connection between the major elements as in a kaleidoscope (rather than a focused beam), allowing room for individual variations.

Sometimes I've wanted to raise a question, suggest a concrete exercise, freshly address an age-old topic, make some unusual juxtaposition, call for a different set of priorities, or quote a particularly moving illustration. I've chosen what I believe to be important spiritual concepts to encourage the reader toward mini-epiphanies regarding the butterfly effect; the virtue of humor; a preferential option for the poor; the value of friendship; slowing down in a speed-obsessed age; the significance of enculturation; keeping a dream diary; doing your own self-inventory; practicing sacred reading; acknowledging both Christ's divinity and humanity; performing symbolic acts; speaking the truth. . . . Theology, spirituality, literature, and ethics are closely interwoven, as in Scripture itself, which contains such diverse genres as law, history, gospel, epistle, psalm, proverb, oracle, short story, and apocalypse. My discussions are not meant to be exhaustive, but represent a potpourri of vital concerns.

To understand the techniques that ancient Roman philosophers and Christian moralists used to instill virtue, German scholar Paul Rabbow recommends one

13 Chapter 9, Thomas Hoover, *Zen Culture* (Vintage, 1978), pp. 113–14.
14 Chapter 4, Robert Wuthnow, *All In Sync: How Music and Art Are Revitalizing American Religion* (University of California Press, 2003), pp. 83–84, 88.

study the life of Ignatius of Loyola. Ignatius sought to mold disciples via a series of exercises which cultivated introspection, encouraged meditation on edifying sayings, nurtured sound habits, and called for the study of noteworthy examples— all under the watchful eye of a master.[15] Such techniques I, too, rely on.

I particularly love pithy sayings. "For what is small and well-put," exclaims the fictional fourteenth-century Spanish archpriest, Juan Ruiz, "sticks in the heart."[16] Gnomic expressions, such as aphorisms or proverbs, bring out basic truths about life as well as provide strategies to achieve them. Often they appear in the present tense, depend on impersonal pronouns and copulative verbs for their impact. Literary devices as symmetry or parallelism, rhythm or rhyme, assonance or alliteration help to affix them in the memory.[17]

Today we are fortunate that so many literary and spiritual masterpieces are available in fluent English translations. For instance, John Mason Neale's renditions of ancient Greek and Latin hymns and Catherine Winkworth's of German hymns have immensely enriched English-speaking liturgy and spirituality since the nineteenth century.[18] "Translators may be compared to busy matchmakers who extol the charms of some half-veiled beauty," Goethe avowed, thus enticing in us "an irresistible longing for the original."[19] But how often do we take advantage of a translator's labors? Scholars, to be sure, carry on original research in their field of specialty, but I long to see pastors and lay people studying materials beyond the tradition in which they grew up, or at least fishing in lesser-known tributaries. The classics are always our contemporaries; so Latin poet Horace urged, "Do you, my friends, study the Greek masterpieces: thumb them day and night."[20]

Finally, if one is going to do something, do it conscientiously. Craftsmanship matters. Anthropologist Bronislaw Malinowski notes how when a Trobriand Islander finds a "specially fine or sportive material" and is "induced to spend a

15 Chapter 11, Robert Louis Wilken, *The Spirit of the Early Christian Thought* (Yale University Press, 2003), p. 268. Cf. Paul Rabbow, *Seelenfuehrung: Methodik der Exerzitien in der Antike* (Kosel-Verlag, 1954).

16 "Of the Characteristics of Small Ladies," J. M. Cohen, editor and translator, *The Penguin Book of Spanish Verse* (Penguin, 1965), p. 14. Cf. "About the Qualities Which Little Women Have," stanza 1606, Juan Ruiz, *The Book of True Love*, translated by Saralyn R. Daly (Pennsylvania State University Press, 1978), p. 397.

17 Chapter 5, Peter Farb, *Word Play* (Bantam, 1979), pp. 117–18.

18 Geoffrey Rowell, "Neale, John Mason," *The Westminster Dictionary of Christian Spirituality*, edited by Gordon S. Wakefield (Westminster Press, 1983), p. 275. Cf. Neale's and Winkworth's translations in Erik Routley (edited and expanded by Paul A. Richardson), *A Panorama of Christian Hymnody* (G.I.A. Publications, 2005).

19 W. B. Ronnfeldt translator, "Reflections and Maxims," *Great Writings of Goethe*, edited by Stephen Spender (New American Library, 1977), p. 274.

20 Edward Henry Blakeney, translator, "The Art of Poetry," *Literary Criticism: Plato to Dryden*, edited by Allan H. Gilbert (Wayne State University Press, 1970), p. 136.

disproportionate amount of labour on it," "he creates an object which is a kind of economic monstrosity, too good, too big, too frail, or too overcharged with ornament to be used, yet just because of that, highly valued."[21] Like the woman who anointed Jesus's feet with exquisite perfume (Jn. 12:1–8), we pour out our lives extravagantly, giving back to God just a tiny portion of what he is due. Too often we have lost the beauty of holiness that the Eastern Orthodox aspire to in worship—meant to be a feast for all the senses before a God of unapproachable splendor. The chants, the incense, the candles, the icons, the vestments, the ornamental books, the architecture help contribute to an overall effect.

Over the centuries the church has been both an active supporter of, and a catalyst for, the arts. "Orgiastic religion leads most readily to song and music"; posited sociologist Max Weber, "ritualistic religion inclines toward the pictorial arts; religions enjoining love favor the development of poetry and music."[22] Why not then, I say, take advantage of that newer medium, photography? In the popular mind photography is esteemed for its realism, simplicity, and truthfulness—qualities we also admire in spiritual writers; so let us fuse the two together. Russian theologian Nikolai Berdyaev considered art to be a creative "break-through into a transfigured world," liberating us "from the ugliness and burden" of mundane existence.[23] It causes one to see this world in a new light as well as to look through and beyond it. Already in the early third century Clement of Alexandria was allowing images of doves, fish, ships, lyres, and anchors to be engraved on Christian signet rings.[24] In creating, we imitate God's own nature, though our materials are far more limited. "What does God do all day long," wondered fourteenth-century Dominican mystic Meister Eckhart: "God gives birth."[25] "[B]y our art," Leonardo da Vinci declared in his notebooks, we "may be called the grandchildren of God."[26]

Throughout, I've tried to approach the reader from unusual angles, referring to forgotten historical figures, drawing your attention to little-known quotations. If one of my devotions should sing in your head, let my footnotes serve as a lantern

21 Chapter 6, Bronislaw Malinowski, *Argnonauts of the Western Pacific* (E. P. Dutton, 1961), p. 173.

22 Chapter 14, Max Weber, *The Sociology of Religion*, 4th edition, translated by Ephraim Fischoff (Beacon, 1993), p. 245.

23 Part III, section 3B, Nikolai Berdyaev, *Slavery and Freedom*, translated by R. M. French (Charles Scribner's Sons, 1944), p. 241.

24 Chapter 1, Jensen, *Face to Face*, p. 10. Cf. Book 3, chapter 11, Clement of Alexandria, *Christ the Educator*, translated by Simon P. Wood (Catholic University of America Press, 1954), p. 246.

25 Matthew Fox, "Eckhart, Meister," *Westminster Dictionary of Christian Spirituality*, ed. Wakefield, p. 124. Cf. Chapter 5, Bernard McGinn, *The Mystical Thought of Meister Eckhart* (Crossroad, 2001), pp. 102–03.

26 Chapter 4, section 2, *Selections from the Notebooks of Leonardo da Vinci*, edited by Irma A. Richter (Oxford University Press, 1977), p. 200.

to guide you to even greater illumination. The church has an immense reservoir of spiritual and artistic treasures that few tap into deeply. Beauty draws us ever heavenward: "But, my God and my glory, for this reason I say a hymn of praise to you," intoned Augustine. "For the beautiful objects designed by artists' souls and realized by skilled hands come from that beauty which is higher than souls; after that beauty my soul sighs day and night."[27]

Almost six centuries ago Andrei Rublev, inspired by Genesis 18, painted an icon of three men (or angels) being entertained by the patriarch Abraham onto the south wall of the sanctuary at the Trinity-Sergius Monastery near Moscow. Opposite it appears the sacrifice of Isaac, since according to Eastern Orthodox tradition, both these motifs deal with the Eucharist. The three graceful figures who represent the Trinity sit at a table with an empty space near the front of the picture. In Greek this icon is called *Philoxenia* (love for/and hospitality to strangers). Indeed, the more you gaze at the work, the more it seems as though the Godhead is actually inviting you, the viewer, into its eternal circle of love.[28] If just one of my meditations had such power, I would become ecstatic. In this book I long for new ways to unite the visual with the verbal, beauty with heartfelt devotion.

"Imprint Christ . . . onto your heart, where he [already] dwells," advised the Byzantine monastic reformer Theodore the Studite, "whether you read a book about him, or behold him in an image; may he inspire your thoughts, as you come to know him twofold through the twofold experience of your senses. Thus you will see with your eyes what you have learned through the words you have heard. He who in this way hears and sees will fill his entire being with the praise of God."[29]

27 Book 10, section 53, Augustine, *Confessions*, translated by Henry Chadwick (Oxford University Press, 1992), p. 210.

28 Chapter 9, Richard Harries, *Art and the Beauty of God* (Mowbray, 1994), pp. 128–29.

29 "The Fathers of the East," Benedict J. Groeschel, *Praying to Our Lord Jesus Christ* (Ignatius, 2004), p. 29. Cf. *S.P.N. Theodori Studitae*, "Epistolae #36, sections C-D," Jacques-Paul Migne, editor, *Patrologia Graeca*, volume 99 (Apud Garnier Fratres Editores, 1903), p. 1213.

Adiaphora, or Things Indifferent

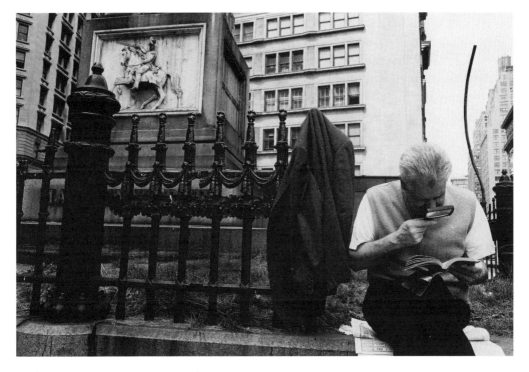

Colossians 2:16–23; 1 Corinthians 10:23–11:1
"God of Grace and God of Glory" by Harry Emerson Fosdick

"Christian liberty teaches us that we are bound by no obligation before God respecting external things, which in themselves are indifferent; but that we may indifferently sometimes use, and at other times omit them."—John Calvin[30]

There are many questions in daily life where the Bible doesn't have a ready answer, where there is neither a direct command nor an outright prohibition, so Christians should feel free to make up their own minds. In his epistles, Paul responded to quite an assortment of issues raised by the new churches: whether to eat food sacrificed to idols (1 Cor. 8); whether one should marry (1 Cor. 7:25–35); whether one day is to be honored above another (Rom. 14:1–12); whether Christian workers should receive remuneration (1 Cor. 9:1–14). His replies demonstrate the degree of latitude permitted in the apostolic church.

30 Book 3, chapter 19, section 7, Hugh T. Kerr, editor, *A Compendium of the Institutes of the Christian Religion* (Westminster, 1964), p. 119. From the John Allen 1813 translation.

The Protestant reformers, following the lead of the patristic fathers, borrowed a term from Stoic philosophy, *adiaphora* ("things indifferent"), when they debated topics such as which elements of Catholicism should be retained (e.g., veneration of the saints, extreme unction), with some adhering to a strict interpretation and others to one more lenient. Controversy erupted again in the seventeenth century, this time among Pietists, over which secular amusements (e.g., opera, theater) believers could participate in—with strenuous arguments raised pro and con.[31] Catholic ethicists, too, since Bartholomeo Medina in 1577, have espoused a view known as "probabilism"—asserting that a doubtful law does not bind, nor may an uncertain law induce obligation—recognizing how there may be several reasonable applications of the moral law within a given context.[32]

Historically, laissez-faire and legalistic Christians have butted heads endlessly. Concerning things indifferent, Paul recommends we ask such questions as: Is what I'm doing helpful, profitable? Will it hurt weaker believers? Does it put an unnecessary stumbling block in front of unbelievers? Has the act been done in good faith? What does conscience say? Ought I to voluntarily renounce my "rights" for the higher sake of the gospel? When Ignatius of Loyola wanted to decide among the options laid before him, he would ask—which is more likely to lead to the "greater" glory of God?[33] All of us need to learn to think on our feet since we can't look up the answers in detailed rulebooks, nor should we line up lockstep with other believers in parade-ground uniforms. Human nature is far too diverse and complicated for God to desire automatons.

King of Kings and Lord of Lords, we live in the concrete here-and-now. Decisions are called for nearly every hour. May our consciences not be unduly fettered by facsimiles of good and evil arbitrarily imposed upon us by overly zealous brothers and sisters. Instead, take us down that path of true liberty carved out by the righteous example of your son.

31 James F. Childress, "Adiaphora," *The Westminster Dictionary of Christian Ethics*, edited by James F. Childress and John Macquarrie (Westminster, 1986), pp. 9–10.

32 Chapter 2, Sheila Briggs, "Conscience and the Magisterium," *Rome Has Spoken*, edited by Maureen Fiedler and Linda Rabben (Crossroad, 1998), p. 28. Cf. Richard A. McCormick, "Probabilism," *The HarperCollins Encyclopedia of Catholicism*, edited by Richard P. McBrien (HarperCollins, 1995), pp. 1054–55.

33 "General Introduction," George E. Ganss, editor, *Ignatius of Loyola: The Spiritual Exercises and Selected Works* (Paulist, 1991), p. 11.

Anagnorisis, or Recognition

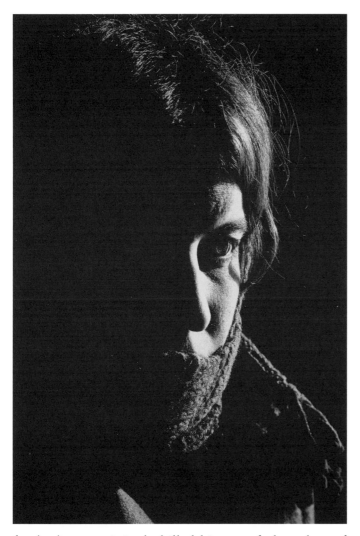

John 9:1–41
"Immortal, Invisible, God Only Wise" by Walter Chalmers Smith

"Man was created for this end, that he might see 'good,' which is God; but because he would not stand in the light, in flying therefrom he lost his eyes; . . . that he should not see the interior light."—Gregory the Great[34]

Aristotle considered "Oedipus the King" by Sophocles to be the model tragedy. In it the king of Thebes investigates why calamity has come upon the city-state. The more he probes, the more his own veiled past is brought into the open. At last it dawns on him that he, himself, has unleashed the contagion, for he has unwittingly killed his own father, then afterwards married his own mother; so in guilt and grief he puts out his eyes. Thus the man who thought he

34 Book 9, section 50 (comments on Job 9:25), Gregory the Great, *Morals on the Book of Job*, Volume 1, translated by Members of the English Church (John Henry Parker & J. G. F. and J. Rivington, 1844), pp. 530–31. Cf. Ronald B. Bond, "Blindness," *A Dictionary of Biblical Tradition in English Literature*, edited by David Lyle Jeffrey (Eerdmans, 1992), p. 94.

could see becomes blind, while the blind prophet Tiresias, who foresaw all that would happen, is revealed to be the true visionary. Aristotle uses the term *anagnorisis* (or "recognition") to describe this turning "from ignorance to knowledge."[35]

In the ninth chapter of the Gospel of John there, too, is a pronounced focus on the imagery of light and darkness. Jesus heals a man blind from birth, whom the Pharisees accuse of lying. Despite the man's unequivocal testimony, they simply refuse to admit Jesus has really cured him. Consequently, Jesus delivers a stern verdict of reversal: "It is for judgement that I have come into this world, so that those without sight may see and those with sight may become blind" (John 9:39 NJB). Pascal puts it bluntly, "There are only two kinds of men: the righteous who believe themselves sinners; the rest, sinners, who believe themselves righteous."[36]

In the story of Samson, the strong man in the Book of Judges, this motif again is at work. With two good eyes Samson abuses the tremendous gifts God has given him; however, once he has been captured by the Philistines and his eyes gouged out, he realizes his dreadful mistake. Although blind, he pleads, "Lord God, remember me and strengthen me only this once" (Judg. 16:28 NRSV). In one final act of retribution Samson pulls down the temple of Dagon upon himself and all of the gathered Philistines (Judg. 16:23–31). This episode displays what has been called, "Biblical realism." Heroes in the Old and New Testament are not saints with haloes, but as literary critic Erich Auerbach explains, "like Adam," they frequently "undergo the deepest humiliation," yet still are "deemed worthy of God's personal intervention and personal inspiration."[37]

You who dwell in light unapproachable, lift this suffocating darkness which enshrouds our every move. In broad daylight we stand as if under the umbra of an eclipse. However, if we contritely acknowledge our blindness, your healing lantern restores our failing vision. Grant unto us, your flawed ones, the gift of unremitting tears.

35 *Poetics*, 11:29–30, *Aristotle's Theory of Poetry and Fine Art*, 4th edition, translated by S. H. Butcher (Dover, 1951), pp. 40–41.

36 Fragment #533, Blaise Pascal, *Pensees* and *The Provincial Letters*, translated by W. F. Trotter and Thomas M'Crie (Modern Library, 1941), p. 170.

37 Chapter 1, Erich Auerbach, *Mimesis*, translated by Willard R. Trask (Princeton University Press, 1973), p. 18.

Animals in Heaven?

Isaiah 11:6–9; 65:17–25

"All Creatures of Our God and King" (*Laudato sia Dio mio Signore*) by Francis of Assisi, translated and adapted by William H. Draper

"What is a charitable heart? It is a heart which is burning with charity for the whole of creation, for men, for the birds, for the beasts, for the demons—for all creatures."—Isaac the Syrian[38]

The present age may end in fire (2 Pet. 3:7), but afterwards God will establish a new heaven and a new earth, perhaps not unlike the peaceable kingdom in American primitive art (e.g., Edward Hicks) or that evoked by the simple, soothing strains in Dvorak's "New World Symphony." And, as Isaiah makes clear, it won't just be for human beings! The wolf will lie down with the lamb and the nursing child play over the hole of an asp (Isa. 11:6–9).

38 Quoted in chapter 5, Vladimir Lossky, *The Mystical Theology of the Eastern Church* (SVS Press, 1976), p. 111. Cf. Chapter 74, Isaac of Nineveh, *Mystic Treatises*, translated by A. J. Wensinck (M. Sandig oHG, 1969), p. 341.

Naturalist John Muir used to complain of those Christians with a "stingy heaven," who had no room at the inn for noble creatures outside of humankind. "Not content with taking all of the earth," he grumbled, "they also claim the celestial country as the only ones who possess the kinds of soul for which that imponderable empire was planned." But God's "charity," Muir believed, "is broad enough for bears."[39] When Martin Luther was asked if there would be animals in paradise, he replied, "You must not think that heaven and earth will be made of nothing but air and sand, but there will be whatever belongs to it—sheep, oxen, beasts, fish." He speculates: "[a]nts, bugs and all unpleasant, stinking creatures will" there become "delightful and have a wonderful fragrance."[40]

Of a Sunday morning we sing "For the Beauty of the Earth," "All Things Bright and Beautiful," "This Is My Father's World," "Morning Has Broken" and speak of sister plant and brother beast. Our concern should embrace all God's creatures, both great and small, those in the wild (e.g., lions in savannas, parrots in rain forests, porpoises in oceans) as well as those in captivity (e.g., domesticated flocks and herds, pets in our homes). We revel in this rich biodiversity and are enchanted by the antics of a favorite mammal or bird. "The righteous know the needs of their animals," insists the Book of Proverbs (12:10 NRSV). How we treat other sentient beings is a litmus test of our capacity as caretakers of creation.

> "O God, my Master, should I gain the grace
> To see you face to face, when life is ended,
> Grant that a little dog, who once pretended
> That I was God, may see me face to face."
> —Francis Jammes[41]

39 "The Philosophy of John Muir," Edwin Way Teale, editor, *The Wilderness World of John Muir* (Houghton Mifflin, 1954), pp. 313–17. Cf. chapter 5, James A. Nash, *Loving Nature* (Abingdon, 1991), p. 124.

40 Quoted in chapter 6, Colleen McDannell and Bernhard Lang, *Heaven: A History* (Vintage, 1990), p. 153.

41 Translated by B. C. Boulter, *The Communion of Saints: Prayers of the Famous*, edited by Horton Davies (Eerdmans, 1990), p. 125. Cf. "L'Eglise Habillee de Feuilles," no. 27 ("Mon humble ami, mon chien fidele, tu es mort") Francis Jammes, *Oeuvre Poetique Complete*, volume 1, edited by Michel Haurie (J. & D. Editions, 1995), pp. 587–88.

Baptizing What's Pagan

Act 17:16–34; 1 Corinthians 9:19–23
"Lead On, O King Eternal" by Ernest W. Shurtleff

The church "has never fostered an attitude of contempt or outright rejection of pagan teachings but, rather, has completed and perfected them with Christian doctrine, after purifying them from all dross of errors."—Pius XII[42]

In A.D. 601 Pope Gregory the Great wrote the monks he had sent to Britain under Bishop Augustine that pagan temples should not be destroyed, but sprinkled with holy water, then Christian altars put inside. Moreover, on church feast days, the people should be allowed to slaughter oxen and to celebrate as in former times.[43] "For it is certainly impossible to eradicate all errors from obstinate minds

42 John XXIII, "Princeps Pastorum," *Classics of Christian Missions*, edited by Francis M. Dubose (Broadman, 1979), p. 397. Cf. "Encyclical Letter on the Promotion of Catholic Missions," (June 2, 1951), *Guide for Living: An Approved Selection of Letters and Addresses of His Holiness Pope Pius XII*, arranged by Maurice Quinlan (Longmans, Green and Co., 1960), p. 242.

43 Chapter 3, Henry Mayr-Harting, *The Coming of Christianity to Anglo-Saxon England*, 3rd ed. (Pennsylvania State University Press, 1991), p. 64.

at one stroke," Gregory determined, since "whoever wishes to climb to a mountain top climbs gradually step by step, and not in one leap."[44] Thus was established the principle of accommodation, or indigenization. Harmless or neutral pagan customs could be tolerated until they were gradually absorbed into Christian rites.[45]

Historically this has meant, for instance, that burial urns became reliquaries; sarcophagi were made into altars; statues of winged victory were turned into angels; and portraits of rulers converted to saints,[46] though surely some concessions did border on the superstitious. In a similar way, Mohammed reworked motifs from the story of Abraham and Ishmael into the pagan rituals of his day, combining ceremonies from individual sites into one all-encompassing annual pilgrimage to Mecca known as the Haj.[47]

Enculturation raises that difficult question: what is indispensable to the Gospel and what is a mere cultural trapping, a throwaway? No "society never existed, in East or West, ancient time or modern," supposes missiologist Andrew Walls, "which could absorb the word of Christ painlessly into its system."[48] In the early church, Jesuit scholar Josef Jungman discerned pagan influences concerning the style and language of liturgical prayers; the symbols depicted in catacomb paintings and sculptures; the practice of kissing holy objects; the use of milk and honey in baptism; the dates actually adopted for festivals and processions; and such conventions as the bridal crown or the funeral meal.[49] A failure to adequately think through these issues would lead later on to such absurdities as South Sea island converts building neo-Gothic sanctuaries and African bishops wearing vestments like the fashionable attire of Europeans.[50]

Translations of the Bible have been paramount in the missionary enterprise for centuries, as people feel most at home at, and freely express themselves, in their own native tongue. That's why Christian worship now takes place in over two thousand different languages—more than that of any other religion. Yale historian Lamin Sanneh notes, "Christianity has been the impulse behind the creation of more dictionaries and grammars of the world's languages than any other force in

44 Book 1, chapter 30, Bede, *Ecclesiastical History of the English People*, translated by Leo Sherley-Price, revised by R. E. Latham (Penguin, 1990), p. 92.

45 D. H. Farmer, "Notes," ibid., p. 365.

46 Chapter 7, Jean Leclercq, *The Love of Learning and the Desire for God*, translated by Catharine Misrahi (Fordham University Press, 1977), p. 159.

47 Chapter 5, "Pilgrimage," Arthur Jeffery, editor, *Islam: Muhammed and His Religion* (Bobbs-Merrill, 1958), p. 199.

48 Chapter 1, Andrew F. Walls, *The Missionary Movement in Christian History* (Orbis, 1996), p. 8.

49 Chapter 11, Geoffrey Wainwright, *Doxology* (Oxford University Press, 1980), p. 373. Cf. chapter 11, Josef A. Jungmann, *The Early Liturgy to the Time of Gregory the Great*, translated by Francis A. Brunner (University of Notre Dame Press, 1959), pp. 122–151.

50 Chapter 22, Alec R. Vidler, *The Church in an Age of Revolution* (Penguin, 1978), p. 252.

history."[51] Then once the Gospel seed has been planted, each cultural/linguistic group can grow and mature, formulating its own Christ-honoring customs.

"O great Lord of the harvest, send forth, we beseech thee, labourers into the harvest of the world, that the grain which is even now ripe may not fall and perish through our neglect. Pour forth thy sanctifying Spirit on our fellow Christians abroad, and thy converting grace on those who are living in darkness. Raise up, we beseech thee, a devout ministry among the native believers."—Robert Milman[52]

51 "Question 61: Answer," Lamin Sanneh, *Whose Religion Is Christianity?* (Eerdmans, 2003), p. 69. Cf. Bruce M. Metzger, "Circulation of the Bible," *The Oxford Companion to the Bible*, edited by Bruce M. Metzger and Michael D. Coogan (Oxford University Press, 1993), p. 122.

52 "The Evangelical and Missionary Revival," Michael Counsell, compiler, *2000 Years of Prayer* (Morehouse, 1999), p. 357.

Bearing a Particle of Light

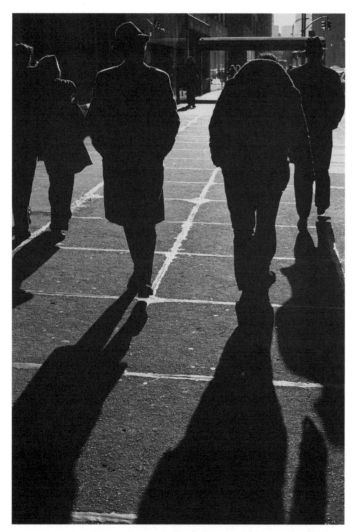

2 Corinthians 5:11–21
"Pass It On" by Kurt Kaiser

"I am obliged to bear witness because I hold, as it were, a particle of light, and to keep it to myself would be equivalent to extinguishing it."—Gabriel Marcel[53]

The church has always been enthusiastic for mission, spreading the good news of Christ's life, death and resurrection. People are looking for what's heartfelt, genuine, so a sincere witness can have far-reaching consequences. Second-century apologist Justin Martyr tells of a conversation he had with an elderly Christian philosopher on the beach near Ephesus, which eventually led to his conversion. Augustine recounts instances in which his mother and others sought to engage him in discussions concerning faith (usually unsuccessfully); then, following a turnabout experience, he recounts instances of his own personal zeal.[54]

53　"Testimony and Existentialism," Gabriel Marcel, *The Philosophy of Existentialism*, translated by Manya Harari (Citadel, 1980), p. 95.
54　Chapter 1, Milton L. Rudnick, *Speaking the Gospel Through the Ages: A History of Evangelism*

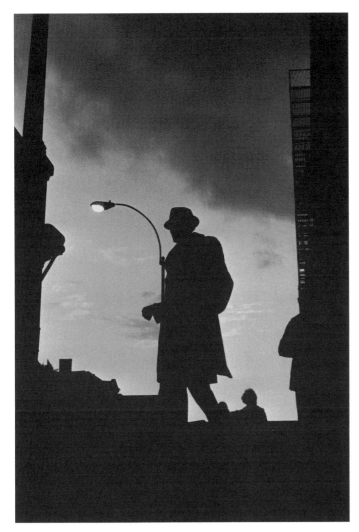

The tinker John Bunyan married a poor woman, whose small dowry contained two devotionals: *The Practice of Piety* by Lewis Bayley and *The Plain Man's Pathway to Heaven* by Arthur Dent. Leafing through these, his soul grew more inclined toward churchgoing and religion; soon thereafter was given birth that allegorical masterpiece *Pilgrim's Progress.*[55] Slave trader John Newton tells of reading *The Imitation of Christ* during a voyage across the Atlantic, then a storm came up; years later, after ordination as an Anglican curate, he wrote that powerful hymn, "Amazing Grace."[56] C. S. Lewis mentions talks he had with Henry Dyson and J. R. R. Tolkien on a September evening in 1931; almost forthwith, he found himself "surprised by joy," becoming the leading exponent for "mere Christianity" in the modern era.[57]

(Concordia, 1988), p. 37. Cf. *Dialogue with Trypho* 3–8, Anne Freemantle, editor, *A Treasury of Early Christianity* (New American Library, 1960), pp. 226–31 and Augustine, *Confessions,* I:11, III:11, V:13, IX:3, etc.

55 "John Bunyan," Hugh T. Kerr and John M. Mulder, editors, *Conversions: The Christian Experience* (Eerdmans, 1983), p. 48. Cf. *Grace Abounding to the Chief of Sinners,* sections 15–16, John Bunyan, *Grace Abounding to the Chief of Sinners and The Pilgrim's Progress,* edited by Roger Sharrock (Oxford University Press, 1966), pp. 10–11.

56 "Amazing Grace," Ian Bradley, editor, *The Book of Hymns* (Overlook, 1989), p. 34. Cf. "Letter 7: Dangers and Deliverances," John Newton, *Out of the Depths* (Keats, 1981), pp. 56–58.

57 Chapter 10, A. N. Wilson, *C. S. Lewis: A Biography* (Fawcett Columbine, 1991), pp. 124–

Such experiences—dramatic, overwhelming, pinpointable, as Paul's encounter on the road to Damascus (Acts 9:1–19)—were likened by eighteenth-century devotional writer William Law to earthquakes which shook the foundations of the soul.[58] Many others, however, have come to faith via a more protracted, meandering route, punctuated by periods of severe doubt.[59] The church, G. K. Chesterton once remarked, "is a house with a hundred gates; and no two men enter at exactly the same angle."[60] Evangelists intent on observing a peculiar manifestation of God's grace or eliciting some stock phrase from a seeker are likely to go away disappointed. Whenever church officials have sought to exalt one type of religious experience as the norm, they have been frustrated and bewildered by the countless ways God molds his chosen vessels. During each person's life, the sense of God's presence ebbs and flows. Psychologically, there are times when people are most responsive to change, so over the ages the church has placed peculiar emphasis on those age-old rites of passage concerning birth (baptism), early adulthood (confirmation), puberty (marriage), and death (funerals).

Giver of light incomparable, send us forth as living candles, who will not be extinguished by the darkness and gloom fomented by the ruler of this world. Excite us to pass on to others that particle of light which has been entrusted to us. Fan our dying embers into a blazing, deep-seated revival.

27. Cf. "To Arthur Greeves," 9/22/31, 10/1/31, 10/18/31, Walter Hooper, editor, *The Collected Letters of C. S. Lewis, Volume 1, Family Letters: 1905–1931* (HarperCollins, 2004), pp. 969–77, 1023.

58 "The Grounds and Reasons of Christian Regeneration," section 20, William Law, *The Works of the Reverend William Law*, Volume 5 (G. Moreton, 1893), p. 152.

59 Chapter 2, Gordon W. Allport, *The Individual and His Religion* (Macmillan, 1967), pp. 37–38.

60 Chapter 2, G. K. Chesterton, *The Catholic Church and Conversion*, edited by James J. Thompson, Jr. (Ignatius, 2006), p. 38. Chesterton is here referring to Catholicism.

"The Beautiful Sight of a Mountain Spring"

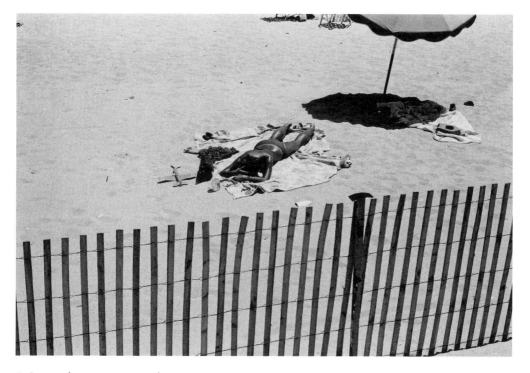

2 Samuel 11:1–5; Matthew 5:27–32

"Great God of Boundless Mercy, Hear" (*Summae Parens clementiae*) anonymous, translated by M. Britt or "O God of Truth, O Lord of Might" (*Rector potens, verax Deus*) anonymous, translated by John Mason Neale

"You must content yourselves with enjoying the beautiful sight of a mountain spring. Do not go beyond that. Do not scoop and soil water, even if it is overflowing" (Japanese tanka rendering of 'Thou shalt not commit adultery')."—Hajime Nakamura[61]

Lust has become rampant in the modern West with leering, nudity, and sexual innuendo commonplace. Those who object are regarded as prudes. But the body is holy, and marriage has been consecrated by a binding vow. Of late, our society has made separation and divorce far too easy, feeling that a child's welfare is best served by the alleged "happiness" of the parents. But divorce, C. S. Lewis declares,

61 Chapter 36, Hajime Nakamura, *Ways of Thinking of Eastern Peoples*, revised and edited by Philip P. Wiener (University Press of Hawaii, 1978), p. 555.

is more like a surgical operation upon a living body than a simple readjustment of two partners, who are free to do as they choose (e.g., 1 Cor. 6:15–20).[62] Too, we have unrealistically postponed marriage far beyond puberty, so that young people may finish their formal education, then winked at early sexual experimentation. But "[t]he traditional portrayal of Cupid, his eyes blindfolded, firing his arrows wildly in all directions," note marriage counselors David and Vera Mace, "reflects long centuries of bitter human experience."[63] Indeed, because of the intense pleasure it gives, sexual intercourse has been always been difficult to control.

I believe stick-to-it-iveness and chastity are still virtues, and tearing asunder marital bonds without a strong, compelling reason is egocentric. "[I]n everything worth having, even in every pleasure, there is a point of pain or tedium that must be survived," observes Catholic essayist G. K. Chesterton, "so that the pleasure may revive and endure. . . . In everything on this earth that is worth doing, there is a stage when no one would do it, except for necessity or honor."[64] Dissimilar personalities will inevitably squabble, yet learning how to handle conflict is crucial to maturity and growth. When things go wrong, do eyes begin to wander, looking for solace and affirmation elsewhere? Does one partner threaten to throw in the towel after some particularly irritating incident? Is either prone to romantic illusions which detract from coping with day-to-day realities? I believe one should maintain one's resolve even when the Sirens are singing.

In the ninth-century poem, "Song of a Modest Woman," Chang Chi tells how an admirer gives a pair of crystal pearls to a married woman, who confesses wistfully, "I am moved by your lingering passion," then proceeds to conceal the gift under her red silk coat. Later, she forthrightly announces, "I return your crystal pearls, while tears fall from my eyes,/ Regretting that we did not meet when I was unmarried."[65] Having sworn to lifelong fidelity, she feels other options are no longer on the table.

"O Lord, grant us grace never to parley with temptation, never to tamper with conscience; never to spare the right eye, or hand, or foot that is a snare to us; never to lose our souls, though in exchange we should gain the whole world."—Christina Rossetti[66]

62 Book 3, chapter 6, C. S. Lewis, *Mere Christianity* (Macmillan, 1968), p. 96.

63 Chapter 5, David and Vera Mace, *Marriage: East and West* (Doubleday, 1960), p. 132.

64 *What's Wrong with the World*, VII: "The Free Family," *The Collected Works of G. K. Chesterton*, volume 4, introduction by James V. Schall (Ignatius, 1987), p. 69.

65 Robert Payne, editor, *The White Pony* (New American Library, 1947), p. 230.

66 "Intercessory Prayers," Tony Castle, compiler, *The New Book of Christian Prayers* (Crossroad, 1986), p. 285.

The Bird Which Renews Itself

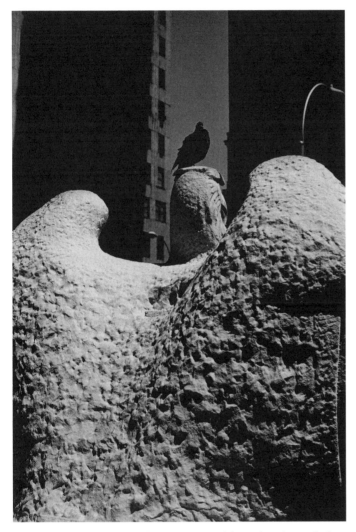

1 Corinthians 15:35–57 "Come, Ye Faithful, Raise the Strain" (*Aisohmen pantes Laoi*) by John of Damascus, translated by John Mason Neale (based on "The Song of Moses" in Exodus 15:1–18) or "Hail Thee, Festival Day" (*Salve festa dies*) by Venantius Fortunatus, translation from the *English Hymnal* (1906)

"How shall the dead arise, . . . to beleeve onely possibilities, is not faith, but meere Philosophy I beleeve that our estranged and divided ashes shall unite againe." —Thomas Browne[67]

The phoenix is a mythological bird. From paintings he saw, the Greek historian Herodotus said its colors were gold and red, and that the shape of its body was like an eagle's.[68] Being the only bird of its kind, it could not reproduce since it had no mate; so once every 500 (or 540 or 1461) years, just as it was about to die, it

67 *Religio Medici*, first part, section 48, *The Prose of Sir Thomas Browne*, edited by Norman J. Endicott (Norton, 1972), p. 55.

68 Book 2, section 73, Herodotus, *The Histories*, translated by Aubrey de Selincourt, revised by A. R. Burn (Penguin, 1975), p. 157.

returned to its birthplace, Heliopolis in Egypt, to renew itself. There it would build a nest of fragrant spices, infuse the germ of life into a ball of myrrh, then acting like some huge solar collector, set itself on fire. Out of the ashes a new phoenix would arise.[69]

This story so impressed patristic fathers like Clement of Rome that they used it as an emblem of Christ's resurrection.[70] The phoenix became a popular symbol in funerary art. The bird's redness calls to mind the blood of martyrs. In mosaics of Christ's second coming it is perched on a palm tree, where it stands for eternal life.[71] A medieval bestiary remarks: "Who tells the simple Phoenix the day of its death—so that it makes its coffin and fills it with fine spices and gets inside and dies in a place where the stink of corruption can be effaced by agreeable smells?"[72]

We believers will one day be revivified like the phoenix—not through any magical powers of our own, but by the hand of him who swirled the universe into being, who embedded matter with life-giving seed. For God to reawaken those

69 Part 7, "The Phoenix," Louis Charbonneau-Lassay, *The Bestiary of Christ*, translated and abridged by D. M. Dooling (Arkana, 1992), p. 445.

70 "The Letter of the Church of Rome to the Church of Corinth, Commonly Called Clement's First Letter," section 25, Cyril C. Richardson, translator and editor, *Early Christian Fathers* (Macmillan, 1976), pp. 55–56.

71 Chapter 5, Margaret Visser, *The Geometry of Love* (North Point, 2001), pp. 99–100.

72 "Fenix," T. H. White, translator and editor, *The Bestiary: A Book of Beasts* (Capricorn, 1960), p. 127.

who have fallen asleep will be as child's play. In "Yellow Spring," modernist Spanish poet Juan Ramon Jimenez eulogizes that rich hue—golden sunshine on the golden water, "yellow butterflies upon the yellow roses," maize-colored garlands climbing up the trunks of trees. He calls this entire scene "a perfumed golden miracle," then ends his lyric on a gentle, but triumphant note: "Among the bones of the dead/God was opening his yellow hands."[73]

> "Christ is risen: the world below is in ruins.
> Christ is risen: the spirits of evil are fallen.
> Christ is risen: the angels of God are rejoicing.
> Christ is risen: the tombs are void of their dead.
> Christ has indeed arisen from the dead,
> the first of the sleepers.
> Glory and power are his for ever and ever. Amen."
> —attributed to Hippolytus[74]

73 "Primavera amarilla," translated by Angel Flores, *An Anthology of Spanish Poetry from Garcilaso to Garcia Lorca*, edited by Angel Flores (Doubleday, 1961), pp. 278–79, 490.
74 "Easter Hymn," A. Hamman, editor, *Early Christian Prayers*, translated by Walter Mitchell (Henry Regnery, 1961), p. 35.

The Butterfly Effect

Luke 19:1–10

"God, Whose City's Sure Foundation" by Cyril Alington

"The HAPPINESS of life . . . is made up of minute fractions—the little, soon-forgotten charities of a kiss, a smile, a kind look, a heartfelt compliment in the disguise of playful raillery, and the countless other infinitesimals of pleasurable thought and genial feeling."—Samuel Coleridge[75]

As MIT scientist Edward Lorenz was making routine weather simulations in 1961, a strange thing happened. He had already run one computer printout, but thought it would be instructive to test again. This time though, he decided to take a short-cut, rounding off the original six-decimal number to three, thinking that a difference of one part in a thousand would prove of little consequence. Instead, minute changes over an extended period completely altered his original forecast. Later he called this "the butterfly effect," suggesting that the flutter

75 "The Improvisatore; or, 'John Anderson, My Jo, John,'" Ernest Hartley Coleridge, editor, *Coleridge: Poetical Works* (Oxford University Press, 1969), p. 466.

of wings on one continent could dramatically affect weather conditions on another. Scientifically it became known as "sensitive dependence on initial conditions."[76]

There is a butterfly effect in human relations as well. Once Jesus noticed an eager onlooker in a sycamore tree, and invited himself to the man's house; salvation came to Zaccheus, soon followed by acts of restitution. But unlike Jesus, we're never sure this side of eternity what effect our actions might have. So, "[i]n the morning sow your seed," advised Qoheleth in Ecclesiastes, "and at the evening let not your hand be idle: For you know not which of the two will be successful, or whether both alike will turn out well" (11:6 NAB). Eighteenth-century Jesuit Jean-Pierre de Caussade spoke of each passing moment as a veil. God was present, but he couldn't be seen with the naked eye: "If we could lift the veil and if we watched with vigilant attention," de Caussade wrote, "God would endlessly reveal himself to us and we should see and rejoice in his active presence in all that befalls us. At every event we should exclaim: 'It is the Lord!' (John 21:7)."[77] Such a welcoming openness to ongoing events is nearly the opposite of that attitude mystic Friedrich von Hügel once characterized as "*sulking through the inevitable.*"[78]

As a cook and a sandalmaker at a Carmelite monastery in seventeenth-century Paris, Brother Lawrence developed a spiritual rhythm which anticipated the butterfly effect: "We must never tire of doing little things for the love of God who considers not the magnitude of the work, but the love," he said.[79] "I flip my little omelette in the frying pan for the love of God. . . . [I]t is enough for me to pick up a straw from the ground for the love of God."[80] His wholehearted devotion to doing even the meanest tasks at the monastery should give us all pause as we formulate our own lists of priorities. Do we truly respect and honor those forgotten ones we encounter each and every day? "[T]hat things are not so ill with you and me as they might have been," concludes George Eliot in her novel *Middlemarch*, "is half owing to the number who lived faithfully a hidden life, and rest in unvisited

76 Chapter 1, James Gleick, *Chaos: Making of a New Science* (Penguin, 1988), pp. 11–31, 322. Lorenz originally used the image of a seagull, but it was his 1979 paper ("Predictability: Does the Flap of a Butterfly's Wings in Brazil Set Off a Tornado in Texas?") which captured the popular imagination.

77 Chapter 2, section 1, Jean-Pierre de Caussade, *Abandonment to Divine Providence*, translated by John Beevers (Image, 1975), p. 36.

78 "To J. M. (a Girl at School)," (September 28, 1910), Baron Friedrich von Hügel, *Selected Letters, 1896–1924*, edited by Bernard Holland (Dutton, 1933), p. 180.

79 Joseph de Beaufort, *Conversations*, "Fourth Conversation (November 25, 1667)," Brother Lawrence of the Resurrection, *Writings and Conversations On the Practice of the Presence of God*, translated by Salvatore Sciurba (ICS Publications, 1994), p. 98.

80 Joseph de Beaufort, *The Ways of Brother Lawrence*, section 10, ibid., p. 116.

tombs."[81] Such lives had made real that petition from *The Book of Common Prayer* (1662) to "joyfully serve thee in all godly quietness."[82]

God of Abraham, Sarah, and Isaac, we know that nothing done in your name is without significance. The smallest task performed to our ability can pry open a crack to let your light shine through. A word of encouragement delivered at an opportune moment can turn a time of despondency into a season of rejoicing. May we who crave recognition not neglect the minuscule to chase after the glamorous.

81 Book 8, "Finale," George Eliot, *Middlemarch*, edited by Gordon S. Haight (Houghton Mifflin, 1968), p. 613.

82 Translated from the Leonine and Gregorian sacramentaries, *The Collects of Thomas Cranmer*, compiled by C. Frederick Barbee and Paul F. M. Zahl (Eerdmans, 2006), p. 78.

Character Is Destiny?

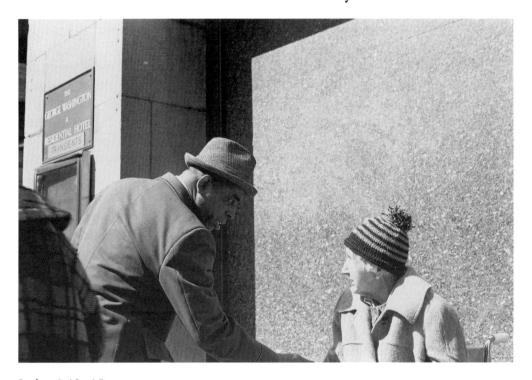

Luke 6:43–45
"Scandalize' My Name" (African-American spiritual)

"What is character but the determination of incident? What is incident but the illustration of character?"—Henry James[83]

Unfortunately, we human beings are not as fluid as romantics would like to have us believe. Inherited genes provide a seedbed for our talents. Upbringing allows for growth in some directions, but not in others. Temperament and personality act like sieves to sort through culture's various options. Finally, our personal values give shape to all that we are and will become. So it's not surprising to hear pre-Socratic philosopher Heraclitus dictate: "A man's character is his destiny."[84]

Each of us is as unique as his own fingerprint. We consist of strands of DNA

83 Chapter 11, "The Art of Fiction," Henry James, *Partial Portraits* (University of Michigan Press, 1970), p. 392.

84 "Fragment 121," translated by Richmond Lattimore, chapter 3, Milton C. Nahm, *Selections from Early Greek Philosophy* (Prentice-Hall, 1968), p. 75.

that can form umpteen combinations. Nobel prize-winning physicist Erwin Schrödinger, who along with Paul Dirac is credited with founding wave mechanics, called the chromosome, which is so essential to a living cell, "an aperiodic crystal." The difference between a periodic (dead) and an aperiodic (living) crystal, he wrote, is akin to the relationship between an ordinary wallpaper pattern, which is repeated over and over, and "a masterpiece of embroidery, such as a Raphael tapestry," where there is "no dull repetition, but an elaborate, coherent, meaningful design."[85]

I believe our destinies are not writ in stone. Character can be revised, modified. One simple way is through goal-oriented behavior which imitates the good wherever we find it. Aristotle felt that habit and training were keys to the formation of character. "For the things we have to learn before we can do them," he wrote, "we learn by doing them."[86] Consider civility. "Politeness does not always imply goodness, equity, obligingness, and gratitude," French essayist La Bruyere pointed out, but "it at least provides the appearance of these, and makes a man seem outwardly what he should be inwardly."[87] When children practice good manners, saying "please" and "thank you," respecting parents and those in authority, they are creating an environment where other virtues can flourish. By being civil to one cranky individual or responding with leniency toward one with whom we normally have a knock-down battle, our self-perception starts to change. This can affect all subsequent behavior. By acting virtuously, one moves in a positive, fruitful direction. When we walk in the light as we see the light, its glowing circle continues to expand.

"Lord, I offer . . . all the sins and offences that I have ever committed . . . from the day of my first sin until now, praying you to burn and consume them all in the fire of your love. Blot out the stains of my sins, and cleanse my conscience from all offences. . . . I offer to you also whatever is good in me, though it be little and imperfect, that you may strengthen and hallow it, make it dear and acceptable to you, and raise it continually towards perfection."—Thomas à Kempis[88]

85 Chapter 1, Erwin Schrodinger, *What Is Life?* and *Mind and Matter* (Cambridge University Press, 1988), p. 5.

86 *Nicomachean Ethics*, book 2, chapter 1, translated by W. D. Ross in *The Basic Works of Aristotle*, edited by Richard McKeon (Random House, 1941), p. 952.

87 Chapter 5, section 32, Jean de la Bruyere, *Characters*, translated by Jean Stewart (Penguin, 1970), p. 89. Cf. Chapter 1, Andre Comte-Sponville, *A Small Treatise on the Great Virtues*, translated by Catherine Temerson (Metropolitan Books, 2001), pp. 10–11.

88 Book 4, chapter 9, Thomas à Kempis, *The Imitation of Christ*, translated by Leo Sherley-Price (Penguin, 1952), pp. 199–200.

"A Choice—The Glorious Treasure"

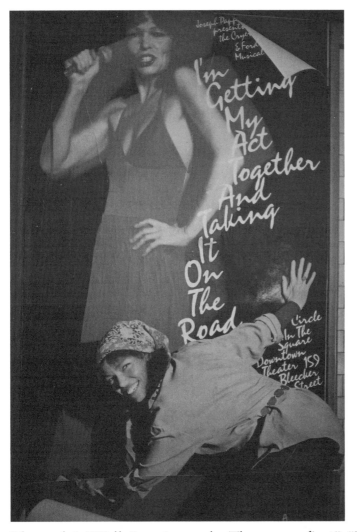

Romans 12:9–21

"Awake, My Soul, and with the Sun" by Thomas Ken or "Here I Am, Lord" by Daniel L. Schutte

"Will we be extremists for the preservation of injustice or for the extension of justice?"—Martin Luther King, Jr.[89]

Citing the parable of the talents (Matt. 25:14–30), a character in one of Charlotte Bronte's novels announces, "Better to try all things and find all empty, than to try nothing and leave your life a blank."[90] There's the story of the Anglican bishop who, while visiting a priest under his supervision, asked how the new charge was going. The reply? "Well, I can't put the Thames on fire!" "What I want to know," the bishop snapped back, "is if we take you out and drop you, will it sizzle?"

89 Chapter 5, Martin Luther King, Jr., *Why We Can't Wait* (New American Library, 1964), p. 88.
90 Chapter 23, Charlotte Bronte, *Shirley*, edited by Andrew and Judith Hook (Penguin, 1983), p. 385.

Those are my sentiments exactly. I find that the greatest enemy to my spiritual life is apathy. A local food bank needs volunteers; some committee at church is looking for a chair; a friend's marriage is on the rocks; an elderly neighbor sits at home, sad and alone. Instead of reaching out with sincere compassion, I prefer the peace and quiet of my own room, spouting rationalizations: "maybe he wants to be by himself"; "someone else is better qualified to help than I am"; "I just don't have the time." By risking nothing, I merely perpetuate the status quo.

But there's a sense of urgency in Jesus's parables; they call into question a lackadaisical attitude. Be alert, be ready; the kingdom of God is near; it's at your very doorstep. "Love anything, and your heart will certainly be wrung and possibly be broken," contends C. S. Lewis. "If you want to make sure of keeping it intact, you must give your heart to no one, not even to an animal. Wrap it carefully round . . .; avoid all entanglements; lock it up safe in the casket or coffin of your selfishness."[91] There it will shrivel up, grow rigid, unbreakable.

"A choice—" Danish philosopher Søren Kierkegaard exclaimed, "is indeed the glorious treasure."[92] Elsewhere he calls "resolution" "a waking up to the eternal."[93] What's crucial, he felt, was to begin, to get under way. Charles Dickens composed this list of sins of omission: "There were many blessings that he had inadequately felt, there were many trivial injuries that he had not forgiven, there was love that he had but poorly returned, there was friendship that he had too lightly prized; there were . . . uncountable slight easy deeds in which he might have been most truly great and good."[94]

In life you cannot be neutral. Confucius praised those who, "[w]hen they see what is good, . . . grasp at it as though they feared it would elude them. When they see what is not good, . . . test it cautiously, as though putting a finger into hot water."[95] We who would be Christ's disciples should heed that admonition of thirteenth-century Franciscan Jacopone da Todi: "Sense and nobleness it seems to me, to go mad for the fair Messiah."[96] Christianity, wrote apologist G. K. Chesterton,

91 Chapter 6, C. S. Lewis, *The Four Loves* (Harcourt Brace Jovanovich, 1960), p. 169.

92 Part 2, section 3, Søren Kierkegaard, *Upbuilding Discourses in Various Spirits*, edited and translated by Howard V. Hong and Edna H. Hong (Princeton University Press, 1993), p. 206.

93 "Against Cowardliness" in *Four Upbuilding Discourses*, Søren Kierkegaard, *Eighteen Upbuilding Discourses*, edited and translated by Howard V. Hong and Edna H. Hong (Princeton University Press, 1990), p. 347.

94 "The Long Voyage," *Dickens' Journalism*, volume 3: "'Gone Astray' and Other Papers," 1851–59, edited by Michael Slater (Ohio State University Press, 1999), p. 190.

95 Book 16, sections 11–12, Arthur Waley, translator, *The Analects of Confucius* (Vintage, 1938), p. 207.

96 "That It Is the Highest Wisdom to Be Thought Mad for Love of Christ," George R. Kay, editor and translator, *The Penguin Book of Italian Verse* (Penguin, 1958), p. 17.

"established a rule and order," so that "good things" could "run wild."[97] Let us recite that petition from the Gregorian Sacramentary: "Stir up we beseech thee, O Lord, the wills of thy faithful people."[98]

I remember your zeal for the Father's will, O Christ. Implant in me that same all-consuming passion.

97 Chapter 6, G. K. Chesterton, *Orthodoxy* (Ignatius, 1995), p. 102.

98 "The Twenty-Fifth Sunday after Trinity," *The Collects of Thomas Cranmer*, compiled by C. Frederick Barbee and Paul F. M. Zahl (Eerdmans, 2006), p. 118.

The Closed Door

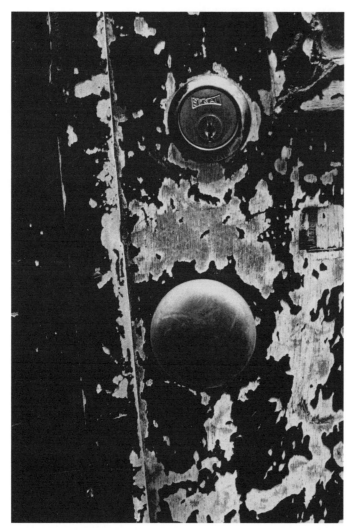

Revelation 3:14–22 "Lift Up Your Heads, Ye Mighty Gates" (*Macht Hoch die Tür*) by Georg Weissel, translated by Catherine Winkworth (based on Psalm 24)

"'Everyone strives to attain the Law,' answers the man, 'how does it come about, then, that in all these years no one has come seeking admittance but me?' The door-keeper perceives that the man is at the end of his strength and his hearing is failing, so he bellows in his ear: 'No one but you could gain admittance through this door, since this door was intended only for you. I am now going to shut it.'"—Franz Kafka[99]

Doors (or gates) symbolize both openness to new possibilities as well as the sealing off of the self, hence are Janus-faced. God calls, but we need ear trumpets to decipher what he's saying. Frequently we equivocate, as when Moses objected that he was not eloquent of speech (Exod. 4:10–12); or when Gideon required a sign to be certain

99 Chapter 9, Franz Kafka, *The Trial*, translated by Willa and Edwin Muir (Penguin, 1972), pp. 236–37.

that God was on his side (Judg. 6:11–24); or when Saul hid himself among the baggage, lest Samuel appoint him king (1 Sam. 10:20–24). We are reluctant to follow a call since we don't know where it will lead or what it might entail, so like a cautious apartment dweller, we squint through our peephole before letting the intruder in.

But Christ "never breaks down" our door, asserts Anglican cleric William Temple. "He stands and knocks. And this is true not only of his first demand for admission to the mansion of the soul; it is true also of every room within that mansion. There are many of us who have opened the front door to him, but have only let him into the corridors and staircases; all the rooms where we work or amuse ourselves are still closed against him."[100] "Oh how hard was my heart that I did not open to you!" laments baroque dramatist Lope de Vega Carpio. "How many times did the angel say to me: 'Now, soul, look out of your window, and you will see how lovingly he persists in knocking!'"[101]

Each life consists of myriads of rooms with numerous doors—some standing ajar, others slammed tightly shut. Perhaps we have let Christ make a difference in who our friends are, but won't let him into our pocketbooks. Maybe we have

100 Chapter 8, William Temple, *Personal Religion and the Life of Fellowship* (Longmans, Green and Co., 1926), p. 79.

101 "Que tengo yo que mi amistad procuras?" J. M. Cohen, editor and translator, *The Penguin Book of Spanish Verse*, revised (Penguin, 1965), p. 247.

allowed Jesus a say in how we raise our children, but think it's none of his business whom we sleep with. We may think God has a few good ideas for handling addictions, but how can he possibly relate to global issues like war and peace, hunger and disease? However, Jesus is not easily dissuaded by our hand-scribbled "Do not disturb" signs; his objective is the inner sanctum. When he manages to fling that door open, his fragrance and sweetness permeate the entire house.

> "I would go near thee—but I cannot press
> Into thy presence—it helps not to presume.
> Thy doors are deeds; the handles are their doing."[102] —George
> MacDonald

102 *A Book of Strife*, "May 16," Rolland Hein, editor, *The Heart of George MacDonald* (Harold Shaw, 1994), p. 221.

Confuting Our Own Observations

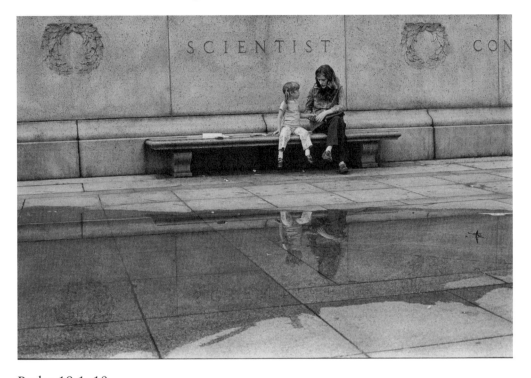

Psalm 19:1–10

"How Great Thou Art" by Stuart K. Hine (loosely based on Carl Boberg's *O Store Gud*) or "The Spacious Firmament on High" by Joseph Addison

"To command the professors of astronomy to confute their own observations is to enjoin an impossibility, for it is to command them not to see what they do see, and not to understand what they do understand, and to find what they do not discover."—Galileo Galilei[103]

There is a good deal of misunderstanding about science in the churches. To many, the empirical method represents an assault upon faith. However hypothesis, observation, measurement, and repeatable experiments have proven a great boon to humankind. Indeed, historians have traced the rise of modern science to the view that there are underlying laws in the universe which can be both

103 "The Authority of Scripture in Philosophical Controversies," George Seldes, compiler, *The Great Quotations* (Pocket, 1972), p. 855. Cf. "Letter to the Grand Duchess Christina," (1615), Stillman Drake, translator, *Discoveries and Opinions of Galileo* (Anchor, 1957), p. 193.

comprehended and articulated—a combination of Greek rationalism and the Judaeo-Christian doctrine of creation.[104] These rules, succinctly summarizing the known data, often take the form of mathematical formulas (e.g., Galileo on accelerated motion, Newton on gravitation, Faraday on electrolysis) offering glimpses into a symmetry below the surface randomness and complexity.

Science concerns probabilities, not dogma. Science "doesn't make any claim to have discovered the ultimate truth," notes Kitty Ferguson. "Scientists speak instead of discovering predictability—of seeking deeper understanding of nature. They don't speak of 'the verdict of science,' but of 'the standard model,' which means the model that nearly all experts agree on at the present time. They speak of 'approximate theories,' which means theories that work satisfactorily in a certain area but do not claim to be the whole truth. . . . They speak of 'effective theories,' which means something we can work with for the present while knowing that it isn't absolutely and unequivocally correct."[105] Scientists express themselves tentatively since they are dealing with what we can be seen and detected, as opposed to making metaphysical statements about the universe, and even they can be startled by findings as bizarre as those uncovered by modern astronomy and quantum physics. A good scientific theory, insists philosopher Karl Popper, makes a number of predictions which can, in principle, be disproved by later observation.[106] If the reasoning is circular, not allowing for falsifiability, you're likely not talking about science, but philosophy.

Clashes between science and Christianity, as when Galileo was censured by Pope Paul V in 1616, are deplorable. Still, "new" knowledge inevitably challenges conventional theories and is difficult to swallow. So, it is heartening to learn that the history of science is replete with mystics and devout believers. "I wanted to become a theologian; for a long time I was restless," announced Johannes Kepler, whose three laws of planetary motion helped to confirm the Copernican theory. "Now, however, observe how through my effort God is being celebrated in astronomy."[107] More precise instruments and new technologies (e.g., microscope, telescope, spectroscope) allow one to perceive wonders never before dreamed of. Should any young person be eager to study God's "second book" (or nature), they are to be commended and encouraged in this most honorable of vocations.

104 Chapter 1, Alfred North Whitehead, *Science and the Modern World* (Free Press, 1967), p. 12.
105 Chapter 2, Kitty Ferguson, *The Fire in the Equations* (Bantam, 1994), p. 26.
106 Part 1, chapter 1, section 6, Karl R. Popper, *The Logic of Scientific Discovery* (Harper & Row, 1965), pp. 40–42.
107 "Letter to Mastlin, October 3, 1595," quoted in Gerald Holton, "Johannes Kepler's Universe: Its Physics and Metaphysics," *Toward Modern Science*, volume 2, edited by Robert M. Palter (Dutton, 1969), p. 483. Cf. chapter 2, Carola Baumgardt, *Johannes Kepler: Life and Letters* (Philosophical Library, 1951), p. 31.

This is your universe, Omniscient Lord. In each of us you have placed a holy curiosity to unravel its googol mysteries. Reveal and illumine its underlying principles, though we know full well that any finding we make is subject to future clarification, modification, even reversal. Before the magnitude and complexity of the cosmos, we bow our heads in awe to an intelligence far greater than our own.

"Dark Satanic Mills"

Romans 8:18–25

"Canticle of Praise to God" (*Venite exultemus*) (Psalm 95:1–7; 96:9,13)

> "And did the countenance divine
> Shine forth upon our clouded hills?
> And was Jerusalem builded here,
> Among these dark Satanic mills?"—William Blake[108]

In nineteenth-century England the factories of the early Industrial Revolution appeared as "dark Satanic mills"[109] to sensitive poet William Blake. Two hundred years later how we treat our environment is no less frightening. We manufacture

108 "From the Preface to *Milton*," Michael Mason, editor, *William Blake* (Oxford University Press, 1988), p. 297.

109 Part II, "William Blake," Marjorie Reeves and Jenyth Worsley, *Favourite Hymns: 2000 Years of Magnificat* (Continuum, 2001), p. 138. Blake was referring to the first great factory in London, the giant Albion flour mill on Blackfriars Road, burned to a blackened ruin in 1791.

products which cannot be readily broken down by natural processes; pollute our water with chemicals which harm innumerable life forms; pave over acre after acre of good farm land to extend our vast network of concrete highways; deplete prairie aquifers; over cultivate rugged hillsides; aggressively cut down age-old forests; too rapidly drain marshes and coastal wetlands. We have let short-term economic gain override the long-range health of the land, abused mother earth in ways which will no doubt prove detrimental for generations.

"They say that where we pass, nothing ever grows again," growls the prospector in Giraudoux's "The Madwoman of Chaillot." "What of it? Is a park any better than a coal mine? What's a mountain got that a slag pile hasn't? What would you rather have in your garden—an almond tree or an oil well?"[110] "[V]iewed objectively, technological progress produces values of unimpeachable merit," French Reformed theologian Jacques Ellul comments, "while simultaneously destroying values no less important."[111] The question we need to ask then is which ones do we want to promote?

Humankind, charged with overseeing creation, is required to be a faithful steward of the land, air, and sea. Having overrun nearly every habitable niche on our

110 "Act One," Jean Giraudoux, *Four Plays, Volume 1*, adapted by Maurice Valency (Hill and Wang, 1958) p. 13.

111 Jacques Ellul, "Technical Progress Is Always Ambiguous," translated by John Wilkinson in *The Borzoi College Reader*, edited by Charles Muscatine and Marlene Griffith (Knopf, 1966), p. 616.

planet's surface, we now should protect fragile ecosystems, preserve endangered species, foster the bountiful earth's variegated splendor. "[I]f you do not allow nets with too fine a mesh to be used in large ponds," the Chinese philosopher Mencius wrote in the fourth century B.C., "then there will be more fish and turtles than the people can eat; if hatchets and axes are permitted in the forests on the hills only in the proper seasons, then there will be more timber than they can use."[112] Common sense and a concern for future welfare are called for. Father Zossima, the starets in Dostoyevsky's *The Brothers Karamazov*, preached that Christians should love the whole of creation, each leaf of it; only then can we truly discern the divine mystery at its core.[113]

Creator God, give us a deep reverence for your earth. Let us perceive your majesty even in a grain of sand, revel in that astounding diversity in the most "barren" landscape. May we preserve pockets of wildness on this bright blue planet, our island home, commending you for each exotic form that life takes. With penitent, distraught hearts, we earnestly beg forgiveness for our countless acts of shortsightedness and our ongoing callous deceit.

112 Book 1, part A, section 3, *Mencius*, translated by D. C. Lau (Penguin, 1970), p. 51.
113 Book 6, Fyodor Dostoyevsky, *The Brothers Karamazov*, volume 1, translated by David Magarshack (Penguin, 1970), p. 375.

Death: Crossing the Final River

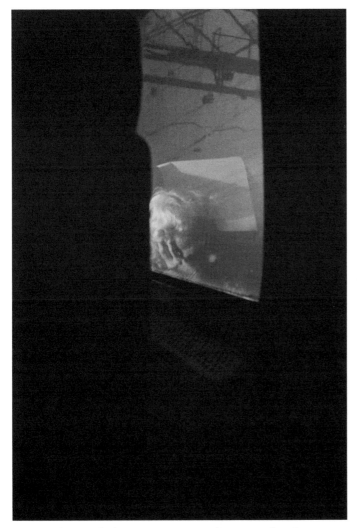

John 21:15–23

"Abide with Me" by Henry Francis Lyte or "Shall We Gather at the River" by Robert Lowry

"These troubles and distresses that you go through in these waters are no sign that God hath forsaken you, but are sent to try you whether you will call to mind that which heretofore you have received of his goodness, and live upon him in your distresses."—John Bunyan[114]

The last enemy the believer faces is death and it can take a heavy toll. I have seen the devout forlorn and perplexed due to anguish and pain from a protracted illness. Old sins come back to haunt them; glaring failures prey upon their minds; sleep grows fitful, tempest-tossed. In Bunyan's allegory, when Christian starts to cross the final river of death, he sinks: "And with that, a great darkness and horror fell upon Christian, so that he could not see before him; also here he in great measure lost his senses, so that he could

114 "First Part," John Bunyan, *The Pilgrim's Progress*, revised, edited by Roger Sharrock (Penguin, 1987), p. 211.

neither remember nor orderly talk of any of those sweet refreshments that he had met with in the way of his pilgrimage." Apparitions of hobgoblins and evil spirits trouble his mind. "[H]earty fears" arise "that he should die in that River, and never obtain entrance in at the Gate."[115]

On the other hand, I have seen those with a seemingly lackluster faith make a smooth, uneventful transition to the other side, as though they were crossing from one room to the next. They appear jubilant, carefree, as if dozing off into a peaceful sleep. To us mortals there is no rhyme or reason to the trials which take place during those last fateful days; God's will appears indistinguishable as a thick fog.

Chapter 21 of John's Gospel makes plain that we have little choice in how we will exit this life—whether as the apostle Peter in the flaming glory of martyrdom or as the beloved disciple simply dying from old age. The river of death is murky, its footing slippery; all that's on the other side is difficult to decipher. We may die instantaneously or end up demented, sickly, or be an invalid for years. To think that a person's fate is somehow sealed by what happens during one's final breath, when his faculties are clouded, is the stuff of fairy tales. Also, any who believe that near-death experiences somehow convey meaningful revelation from another realm are themselves hallucinating. To Boswell's question, "whether we might not fortify our minds for the approach of death," Samuel Johnson snapped: "'No, Sir, let it alone. It matters not how a man dies, but how he lives. The act of dying is not of importance, it lasts so short a time.'"[116] The hour of our death and our last dying words are not nearly so significant as the kind of life which preceded them.

"My soul, one day you will leave this body. When will it be? In winter or in summer? In the city or in the country? By day or at night? Suddenly or after due preparation? From sickness or by accident? Will you have time to make your confession or not? . . . Unfortunately, we know nothing whatsoever about all this. Only one thing is certain: we will die and sooner than we think. . . . Lord, take me under your protection on that dreadful day."—Francis de Sales[117]

115 Ibid., pp. 210–11.

116 "26 October 1769," James Boswell, *The Life of Samuel Johnson* (Modern Library, no date), p. 366.

117 "The Fifth Meditation—On Death," Francis de Sales, *Introduction to the Devout Life*, translated and edited by John K. Ryan (Image, 1972), pp. 60–61.

Despising What We Do Not Understand

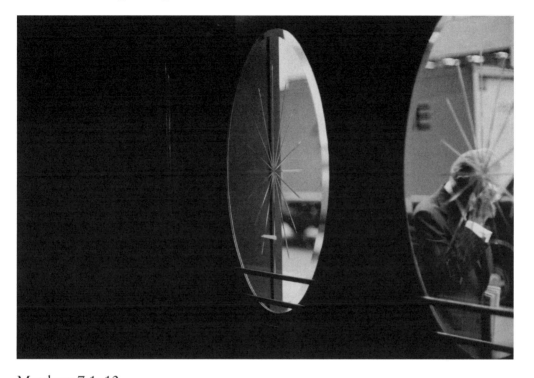

Matthew 7:1–12

"There's a Wideness in God's Mercy" by Frederick W. Faber

"Everybody complains of his memory, but nobody of his judgment."—Francois, duc de La Rochefoucauld[118]

In Flannery O'Connor's short story, "Revelation," Ruby Turpin, a white, middle-class, southern Christian, takes her husband to the doctor. In the waiting room she affably interacts with other patients, yet all the while is judging them internally. One woman tells how she bought "some joo'ry" with green stamps; to which Ruby mutters, "Ought to have got you a wash rag and some soap." A young girl who rubs Ruby the wrong way turns out to be a college student up north; to which Ruby responds, "[W]ell, it hasn't done much for her manners." A mother relates how her little boy has had an ulcer since birth and has never given her a moment's peace, still, she does manage to feed him

118 # 89, Francois, duc de La Rochefoucauld, *Maxims*, translated by Leonard Tancock (Penguin, 1981), p. 48.

"Co' Cola and candy," to which Ruby soliloquizes, "That's all you try to get down" him.

In Ruby's scheme of things "colored people" and "white-trash" are the dregs of society; just above them are "home-owners"; on a higher level are "home-and land-owners" like Claud and herself. Eventually, nearby her pigpen, Ruby has an epiphany when God smashes these preconceived notions to smithereens.[119] She is what Anglican divine William Temple might call a saint with blind spots.[120] Although Ruby sincerely follows her Lord, like so many of us, she never quite triumphs over flagrant personal flaws.

The nineteenth-century philosopher John Stuart Mill formulated a maxim to the effect that we are mostly right in what we affirm, and mostly wrong in what we deny.[121] Our heads are full of airtight categories; we promulgate our own patented elixirs and make snap judgments before all relevant facts are known. But just as the eye requires shadows to carefully delineate whatever object it perceives,[122] so we sinners need full, nuanced information before rendering a verdict on someone else's ideas. Even then, it might take an eloquent devil's advocate for us overgeneralizing prima donnas to sympathize with a viewpoint different from our own. "[I]n our dealings with one another," Temple counseled, "let us be more eager to understand those who differ from us than either to refute them or to press upon them our own tradition."[123] It is better to listen than to censure, since our myopias are legion.

"Lord, help me not to despise or oppose what I do not understand."—attributed to William Penn[124]

119 "Revelation," Flannery O'Connor, *The Complete Stories* (Farrar, Straus and Giroux), 1980, pp. 492, 498, 497, 491, 508–09. Cf. Chapter 2, Robert Barron, *The Strangest Way* (Orbis, 2002), pp. 70–72.

120 Chapter 8, William Temple, *Personal Religion and the Life of Fellowship* (Longmans, Green and Co., 1926), p. 81.

121 "Coleridge," *Mill on Bentham and Coleridge*, introduced by F. R. Leavis (George W. Stewart, 1950), p. 105.

122 Chapter 10, R. L. Gregory, *Eye and Brain*, third edition revised and updated (McGraw-Hill, 1978), pp. 182–87.

123 A. R. Vidler, "Temple, William," *The Westminster Dictionary of Christian Spirituality*, edited by Gordon S. Wakefield (Westminster, 1983), p. 374.

124 "The Seventeenth Century," Michael Counsell, compiler, *2000 Years of Prayer* (Morehouse, 1999), p. 295.

A Dream Diary

Genesis 37:1–11

"Lord of All Hopefulness, Lord of All Joy" by Jan Struther or "Creator of the Earth and Sky" (*Deus creator omnium*) by Ambrose, translated by Charles Bigg

"'I should like to sail on the lake,' runs the wish which gives rise to the dream; the content of the dream itself is: 'I am sailing on the lake.'"—Sigmund Freud.[125]

Do dreams come from God? The third-century Latin father Tertullian believed, "It is to dreams that the majority of mankind owe their knowledge of God."[126] The great Alexandrian theologian Origen declared that many had been converted

125 "Eighth Lecture," Sigmund Freud, *A General Introduction to Psychoanalysis*, translated by Joan Riviere (Pocket, 1969), p. 136.

126 Quoted in chapter 2, E. R. Dodds, *Pagan and Christian in an Age of Anxiety* (Norton, 1970), pp. 38, 46. Cf. "On the Soul," 47:2, *Tertullian: Apologetical Works and Minucius Felix: Octavius*, translated by Rudolf Arbesmann, Emily Joseph Daly, Edwin A. Quain (Catholic University Press, 1962), p. 285.

to Christianity via dreams or waking visions.[127] Jerome, after a dream in which he was punished for being more of a Ciceronian (who loved pagan literature) rather than a Christian (who loved Scripture),[128] proceeded to mend his ways, translating the Bible into Latin, a version which became known as the Vulgate, that was to be standard in the Western church for centuries. Most ordinary dreams, the church fathers realized, of course, were due to natural causes.

In modern psychology, dreams frequently represent a land of make-believe, even turn into self-fulfilling prophecies. The optative "I should like to sail" becomes the indicative "I am sailing." Caspar Milquetoast becomes a Sir Galahad or a Don Juan, while some frail wallflower is turned into a Joan of Arc or a Miss Universe. Freud referred to this phenomenon as "wish-fulfillment."[129] Dreams expose both gnawing conflicts and secret motives, our self-loathing as well as self-love.

On one level, the dreams of Joseph in Genesis where sheaves of grain (as well as the sun, moon, and eleven stars) bow down to him, are prophetic. On another level, (and Jacob doesn't miss this!) they also betray Joseph's own ambition. (This same type of ambiguity may underlie that turning-point dream, or vision, of the Emperor Constantine, which urged him to conquer in the sign of the cross at the battle of Milvian Bridge.[130]) Dreams aren't some direct conduit to the celestial realm, since they are easily distorted by our subconscious. However, by collecting and analyzing these nightly signals, we can learn to identify recurring motifs and overarching symbols which probe into our unseen depths. So, why not start your own dream diary as one possible means of self–analysis? You can do this by jotting down whatever you remember, even if it's just fragments, then drawing pictures of the images you've seen, comparing them to waking life.[131]

Teach us, O Self-Revealer, to distinguish true dreams which (as the ancient Greeks supposed) enter through the gates of horn, from false ones originating beyond the gates of ivory.[132] Enable us to assess and interpret that ever-churning cauldron, our inner self, so that we may break free from the clanking chains of our fears. Prevent the evil one from subverting your good purposes. May we never mistake personal obsessions for your directive will.

127 Book 1, section 46, Origen, *Contra Celsum*, translated by Henry Chadwick (Cambridge University Press, 1980), p. 42.

128 "To Eustochium," John Cumming, editor, *Letters from Saints to Sinners* (Crossroad, 1996), pp. 59–60. Cf. "Letter 22," section 30, Charles Christopher Mierow, translator, *The Letters of St. Jerome*, volume 1 (Newman Press, 1963), pp. 165–66.

129 "Ninth Lecture," Freud, *A General Introduction*, p. 143.

130 Lactantius, *On the Death of the Persecutors*, 44:3–6, J. Stevenson, editor, *A New Eusebius*, revised by W. H. C. Frend (SPCK, 1999), pp. 283–84.

131 James L. Empereur, "Dreams," Michael Downey, editor, *The New Dictionary of Catholic Spirituality* (Liturgical, 1993), pp. 294–97.

132 Book 6, lines 893–98, *The Aeneid of Virgil*, translated by Allen Mandelbaum (Bantam, 1972), p. 162. Cf. Homer, *The Odyssey*, book 19, lines 560–69.

"Dwarfs Mounted on the Shoulders of Giants"

Hebrews 11:1–16

"For All the Saints" by William Walsham How or "I Sing a Song of the Saints of God" by Lesbia L. Scott

"We are as dwarfs mounted on the shoulders of giants, so that although we perceive many more things than they, it is not because our vision is more piercing or our stature higher, but because we are carried and elevated higher thanks to their gigantic size."—Bernard of Chartres[133]

We are part and parcel of all that has gone before, and depend on family, friends, and associates for sustenance and insight. It takes an entire village to nurture our myriad and sundry needs. Catholic essayist G. K. Chesterton once referred to tradition as "democracy extended through time." It "means giving votes to the most obscure of all classes, our ancestors . . . Tradition refuses to submit to the small and arrogant oligarchy of those

133 Quoted in chapter 7, Jean Gimpel, *The Medieval Machine* (Penguin, 1980), pp. 147–48. Cf. book 3, chapter 4, John of Salisbury, *The Metalogicon*, translated by Daniel D. McGarry (University of California Press, 1955), p. 167.

who merely happen to be walking about,"[134] hence serves to broaden our perspective.

That great exponent of "mere Christianity," C. S. Lewis, believed one of the best ways to compensate for the deficiencies and the parochial attitudes of one's era is to read books from earlier centuries. These previous writers weren't any brighter than we are, but they just didn't make the same mistakes we do, nor in exactly the same way: "Two heads are better than one," Lewis concluded, "not because either is infallible, but because they are unlikely to go wrong in the same direction."[135] By reading books from authors who lived in other eras, we form a mental grid that shields us from uncritically succumbing to the spirit of the age.

Dominican theologian Yves Congar compared tradition to a broad and flowing river.[136] It sets forth the broad contours of the faith—depicting which directions have generally led to greater illumination and which have more often proven to be dead ends. The force of this ongoing stream is likely to overwhelm any who agitate for large-scale change, since carried to extremes, such actions may incite new forms of demagoguery. Tradition, however, shouldn't put a damper on new promptings by the Spirit. In our day we have witnessed barriers of race broken down, anti-Semitism acknowledged, women and minorities put into significant positions of power. No doubt these movements have caused much anxiety and pain, but they have also granted access to those previously on the margins. Rightly understood, tradition means holding on to what's vital, while being open to what's emerging, the avant-garde.

"Rome, with voices panegyrical, praises Peter and Paul through whom they came to believe in Jesus Christ, the Son of God; Asia, Ephesus, and Patmos praise John the Theologian; India praises Thomas; Egypt, Mark. All lands, cities, and men honor and glorify their teacher who brought them the Orthodox Faith. Thus, let us, through our own strength, humbly praise our teacher and mentor."—Metropolitan Hilarion[137]

134 Chapter 4, G. K. Chesterton, *Orthodoxy* (Ignatius, 1995), pp. 52–53.

135 "On the Reading of Old Books," C. S. Lewis, *God in the Dock*, edited by Walter Hooper (Eerdmans, 1994), p. 202.

136 "The Magisterium of the Hierarchy: The Chief Subject of Tradition," Yves Congar, *The Meaning of Tradition*, translated by A. N. Woodrow (Ignatius, 2004), p. 65.

137 "The Eulogy to Our Kagan Vladimir," Serge A. Zenkovsky, editor and translator, *Medieval Russia's Epics, Chronicles, and Tales*, revised and enlarged (Meridian, 1974), p. 88.

Education: Augmenting Excellence

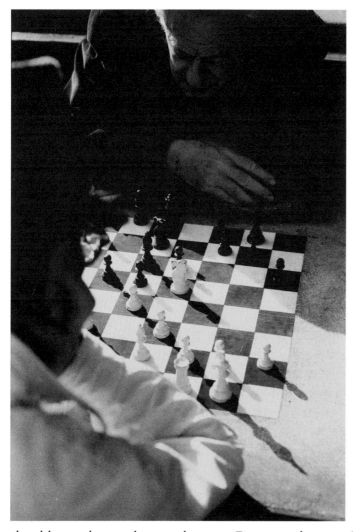

1 Kings 3:3–15; 4:29–34
"Awake, My Soul, Stretch Ev'ry Nerve" by Philip Doddridge

"The first motive which ought to impel us to study is the desire to augment the excellence of our nature, and to render an intelligent being yet more intelligent."—Baron de Montesquieu[138]

Education enables us to learn of remote times, visit unfamiliar cultures, and opens up new modes of thought. By pursuing a certain field of study, then drawing on research from neighboring disciplines, we can more fully integrate our faith with our knowledge. Learning should ever be encouraged, provided it is put to good use. We should stretch ourselves, and not, as Dostoyevsky caustically put it, merely "keep out of the rain."[139] Since, for centuries, women were given little opportunity for formal study, it is only fitting that one of the finest defenses of education is from

138 Quoted in Chapter 1, "Sweetness and Light," Matthew Arnold, *Culture and Anarchy*, edited by J. Dover Wilson (Cambridge University Press, 1969), p. 44.

139 *Notes from Underground*, Part I, Section 10, Fyodor Dostoyevsky, *Three Short Novels*, translated by Constance Garnett (Dell, 1973), p. 54.

the hand of a seventeenth-century nun who showed an extraordinary curiosity from an early age. Sor Juana Ines de la Cruz—who relished such subjects as science, music, and literature—came to be regarded as one of the great poets of the age, being known as "the Tenth Muse" of New Spain.[140]

She thought education necessary just to understand and appreciate the Bible: "How, lacking logic, was I to understand the general and specific methodologies of which Holy Scripture is composed?" asks Sor Juana. "How, without rhetoric, could I understand its figures, tropes, and locutions? . . . How, lacking arithmetic, could one understand such mysterious computations of years, days, months, hours, weeks, as those of Daniel and others . . . How, without geometry, could one measure the sacred ark of the covenant and the holy city of Jerusalem, whose mysterious measurements form a cube in all its dimensions . . . How, without a knowledge of architecture, is one to understand Solomon's great temple . . . How will one understand the historical books without a full knowledge of the principles and divisions of which history consists? . . . How will one understand the legal books without a complete acquaintance with both codes of law?"[141]

We need humility in recognizing how much we don't know, diligence in overcoming our deficiencies, plus the critical acumen to evaluate a given subject matter. The Benedictine scholar Jean Leclercq felt that while grace elevates and enriches the soul, it is culture that refines and embellishes our capacity to benefit others.[142] Education is particularly crucial during those formative years when our minds are pliable and can readily absorb new findings, but it should also mushroom into a lifelong pursuit where, as Ecclesiasticus has it, we turn into "lovers of learning."[143]

"Hear our prayers, Lord Jesus, the everlasting Wisdom of God the Father. You give us, in our youth, aptness to learn. Add, we pray, the furtherance of your grace, so to learn knowledge and the liberal sciences that, by their help, we may attain to a fuller knowledge of you, whom to know is the height of blessedness; and by the example of your boyhood, may duly increase in age, wisdom and favor with God and man."—Desiderius Erasmus[144]

140 Chapter 25, Amy Oden, editor, *In Her Words* (Abingdon, 1994), p. 239.

141 "The *Reply to Sor Philothea*," Alan S. Trueblood, translator, *A Sor Juana Anthology*, (Harvard University Press, 1988), pp. 213–14.

142 "Epilogue," Jean Leclercq, *The Love of Learning and the Desire for God*, translated by Catherine Misrahi (Fordham University Press, 1977), p. 315.

143 The Apocryphal/Deuterocanonical Books, "The Prologue," *The New Oxford Annotated Bible with the Apocrypha* (NRSV), revised and enlarged, edited by Bruce M. Metzger and Roland E. Murphy (Oxford University Press), 1991, p. 87.

144 "Occasional Prayers," Tony Castle, compiler, *The New Book of Christian Prayers* (Crossroad, 1986), p. 298. Cf. "The Humanists," Michael Counsell, compiler, *2000 Years of Prayer* (Morehouse, 1999), p. 173.

"Fed on Sweets Too Long"

Amos 8:1–14

"The Battle Hymn of the Republic" by Julia Ward Howe or "O God of Earth and Altar" by G. K. Chesterton

"I'm sorry, but people have been fed on sweets too long and it has ruined their digestion. Bitter medicines and harsh truths are needed now."—Mikhail Lermontov[145]

In ancient Palestine seers referred to themselves as lookouts or watchmen, warning Israel of impending doom from within and without (Isa. 21:6–10; Jer. 6:17, Ezek. 3:17–21).[146] In calling their kith and kin back to the obligations of the covenant, they railed against immoral conduct, societal breakdown, the worship of foreign gods, abuse by political and religious officials—all the while exalting

145 "Author's Preface," Mikhail Lermontov, *A Hero of Our Time*, translated by Paul Foote (Penguin, 1981), p. 20.
146 Volume 3, "The Prophet," Johs. Pedersen, *Israel: Its Life and Culture*, volumes 3–4 (Oxford University Press, 1973), p. 136.

the faithfulness of God.[147] To enter into the mindset of an Old Testament prophet, why not rewrite some striking passage in your own modern paraphrase, pointing out similar sins in our day? Here's my rendition of portions of Amos 8:

"'Lord, what's this sword hanging above my head?' Then he boomed out to me the prophet, Ken: Your sins have too long gone unpunished. My wrath must be poured out on this nation's idolatry. . . . And here's the rub. Listen, you greedy fakers who sleep in air-conditioned pews on Sunday, so you can spit on the needy all week long to cool them off. . . . Woe to you loan companies who make poor risks lifelong dependents! And you cigarette manufacturers who tout toxic substances as health food! And you slumlords, who willfully ignore the safety and welfare of your tenants! Surely I, the Lord, will never forget these rebellious deeds (though your history books may whitewash them).

"The entire land will tremble under the weight of my judgment like a quavering San Andreas fault. Blackouts will engulf city after city. I'll convert your revelries into crying contests and your hallelujah choruses into sobbing chants. You will wander from place to place traumatized, and your mourning will be as for the death of an only child. . . . Even America's sturdiest youth will give out in exhaustion. On that day those who swear by Scorpius and the signs of the zodiac, those who flock to cultic demagogues, and any who pin their hopes on staid ritual or charismatic hoopla—will be bowed low in destruction."

Almighty and ever-living judge, we have gorged ourselves on feel-good bromides and pat-ourselves-on-the-back platitudes for far too long; now we must feel the sting of your righteous indignation. "For when I see his vineyard overgrown with thorns, brambles, and weeds, I know that everlasting woe appertains unto me, if I hold my peace, and put not to my hands and tongue, to labour in cleansing his vineyard. . . . It pities me to see the simple and hungry flock of Christ led into corrupt pastures, carried blindfold, they know not whither, and fed with poison in the stead of wholesome meats. And, moved by the duty, office, and place, whereunto it hath pleased God to call me, I give warning in his name."[148]—Thomas Cranmer

147 Robert R. Wilson, "Prophet," *The HarperCollins Bible Dictionary*, revised, edited by Paul J. Achtemeier (HarperCollins, 1996), p. 888.

148 "A Defence of the True and Catholic Doctrine of the Sacrament of the Body and Blood of our Saviour Christ," (preface), *Writings of Thomas Cranmer* (The Religious Tract Society, no date), pp. 225–26.

"Giant of a Double Nature"

Colossians 1:15–20; Philippians 2:5–11 "Crown Him with Many Crowns" by Matthew Bridges and Godfrey Thring or "O Come, All Ye Faithful" (*Adeste, fideles*) by John Francis Wade and Etienne Borderiers, translated by Frederick Oakeley and others

"Rise now out of that wedding chamber,
From that royal hall of modesty,
You giant of a double nature
And run your course rejoicingly."—Ambrose[149]

Defining Christ's nature was a perplexing problem for the early church. The classic definition from the Council of Chalcedon in A.D. 451 undercut rival positions expressed by Arians, Nestorians, Apollinarians, and Eutychians: "We all unanimously teach . . . one and the same Son, our Lord Jesus Christ, perfect in deity and perfect in humanity . . . in two natures, without being mixed, transmuted, divided, or

149 "Veni, redemptor gentium," fourth stanza, James J. Wilhelm, editor and translator, *Medieval Song* (Dutton, 1971), p. 35.

separated."[150] This wording arose from questions concerning Christ's pre-incarnate life; the exact relationship between his two natures; the lasting effects of the incarnation; how members of the Trinity interacted; and so on. It served to affirm Christ's oneness with God, oneness with humanity, and the oneness of his own person, and came to be accepted by nearly all branches of Christianity.

Here's how the prominent early church orator John Chrysostom portrayed this balance: "When you hear of Christ, do not think him God only, or man only, but both together. For I know Christ was hungry, and I know that with five loaves he fed five thousand men, besides women and children. I know Christ was thirsty, and I know Christ turned water into wine. I know Christ was carried in a ship, and I know Christ walked on the waters. I know Christ died, and I know Christ raised the dead."[151] He both performed miracles, asserted Leo the Great, as well as suffered insults.[152] "The unbounded Word was complete among men below," proclaims the Akathistos hymn to Mary as the Theotokos, "and from heaven above never absent."[153] Christ's body was genuine flesh-and-blood, not a phantom; his divine nature "emptied" somewhat (cf. Phil. 2:7), but still active.

To symbolize Christ as fully God and fully human, medieval writers resorted to such fabulous beasts as the griffin, whose lion-like body dominated the earth and whose eagle-like head and wings dominated the heavens.[154] In Dante's *Purgatorio* (canto 29), a griffin appears pulling a chariot which stands for the ideal church. The lion-like portion (representing his humanity) is white, suggesting purity, and crimson, pointing to his Passion. The eagle-like portion (representing his divinity) is gold to symbolize incorruptibility.[155] Only near the end of the Paradiso (canto 33), could Dante (who felt like a geometer trying to square the circle) catch a simultaneous glimpse of both Christ's divinity and humanity.[156] Though God may be depicted, analyzed, and comparisons drawn of him, we finite beings can never fully fathom his essence.

150 "Incarnation," Jaroslav Pelikan, *The Melody of Theology* (Harvard University Press, 1988), pp. 141–42. Cf. "The Definition of Chalcedon," Henry Bettenson and Chris Maunder, editors, *Documents of the Christian Church*, 3rd ed. (Oxford University Press, 1999), p. 56.

151 Quoted in chapter 18, Spiros Zodhiates, *Was Christ God?* (Eerdmans, 1970), p. 91.

152 "*The Tome of Leo*," Bettenson and Maunder, eds., *Documents of the Christian Church*, p. 56.

153 "The Akathistos Hymn," Constantine A. Trypanis, editor and translator, *The Penguin Book of Greek Verse* (Penguin, 1979), p. 383.

154 "Griffin," Hans Biedermann, *Dictionary of Symbolism*, translated by James Hulbert (Facts on File, 1992), p. 159. Cf. Section 2:17, Isidore of Seville, *Etymologies*, book 12, translated and edited by Jacques Andre (Paris: Les Belles Lettres, 1986), pp. 100–101.

155 Dante Alighieri, *The Divine Comedy: Purgatorio*, translated with commentary by Charles S. Singleton (Princeton University Press, 1982), pp. 320–23, 718–19.

156 Joseph Gallagher, *To Hell and Back with Dante* (Triumph, 1996), pp. 118, 123, 201.

Son of man/Son of God, your unexpected incongruities awe and bewilder us. You are a strange composite of startlingly discordant elements eternally yoked together. Any words we come up with to describe your nature must be stretched to the breaking point, since you are nonpareil. Fact is stranger than fiction, for your reality far outstrips any of our weak imaginings.

Gutenberg, Our Patron Saint

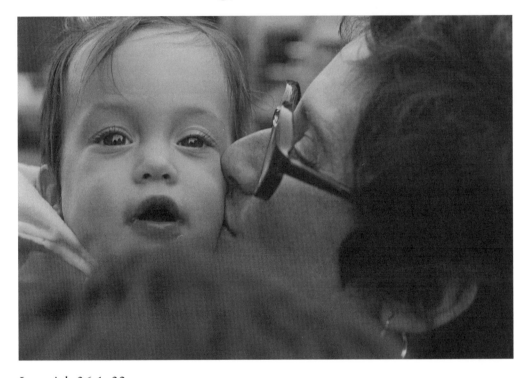

Jeremiah 36:1–32

"Open My Eyes, That I May See" by Clara H. Scott

"For books are not absolutely dead things, but do contain a potency of life in them to be as active as that soul was whose progeny they are."—John Milton[157]

In early medieval Europe the large monasteries had a special room called a *scriptorium* set aside for dedicated and gifted monks who worked as scribes, illuminators, and bookbinders. The rooms had large windows so plenty of light could come through, as well as good heating so fingers didn't cramp up in winter. Among the luminaries who held these esteemed positions were Patrick, Columba, and Eadfrith.

Faithfully copying out ancient texts, the scribe strove to develop a graceful, uniform handwriting. Pens were formed from the feathers of large birds (usually geese or swans). He or she learned to sharpen a quill so as to form a good nib, how to scrape away mistakes and to add insertions in the margins. While the body

157 "Areopagitica," Douglas Bush, editor, *The Portable Milton* (Viking, 1964), p. 155.

of the text would often be in black ink, chapter headings (and other divisions) could stand out in red.

When a task was completed, the scribe might sign his or her name at the bottom, compose a special prayer of thanksgiving, boast a bit, or complain of a sore back. Teamwork was important, particularly in the case of illuminated manuscripts. Much of our knowledge of ancient Greek and Roman classics is due to these dedicated craftsmen. Without their tireless efforts, we might have lost the works of Aesop, Aristotle, Plato, Cicero, Homer . . .[158]

We who are bibliophiles, anxious to pay homage to these labors, concur with poet Christopher Smart, "For I bless God in the libraries of the learned & for all the booksellers in the world."[159] Perhaps then we should make Johann Gutenberg, the German goldsmith who invented movable type, our patron saint. By making individual metal letters of the alphabet, he was able to spell out any text, lock the type in place, and print whatever document was needed. Afterwards these same letters could be rearranged and reinked over and over. It "became possible," notes art historian Christopher de Hamel, "to multiply written words in infinite quantity and in identical copies."[160] Thus, information could be disseminated widely, squeezed into a compact form, and sold at a reasonable cost. In fact, literacy has become *the* key to the world's knowledge, and its artifact, the book, the emblem of culture.

In *Doctrinale Juvenum* Thomas à Kempis recommends: "Take thou a book into thine hands as Simeon the Just took the child Jesus into his arms to carry him and kiss him. And when thou hast finished reading, close the book and give thanks for every word out of the mouth of God; because in the Lord's field thou hast found a hidden treasure."[161] Let us, one and all, lift a toast to every author who has touched the godly center of our lives.

158 Elizabeth B. Wilson, *Bibles and Bestiaries* (Farrar, Straus and Giroux, 1994), pp. 11, 25–26, 45.

159 "Fragment B1, line 79," Christopher Smart, *Jubilate Agno*, edited by W. H. Bond (Harvard University Press, 1954), p. 53.

160 Chapter 8, Christopher de Hamel, *The Book: A History of the Bible* (Phaidon, 2001), p. 190.

161 Quoted in "Preface," Richard de Bury, *The Love of Books: The Philobiblon*, translated by E. C. Thomas (Cooper Square, 1966), p viii.

"A Hallelujah from Head to Foot"

2 Chronicles 5:2–14; Psalm 100

"Joyful, Joyful, We Adore Thee" by Henry Van Dyke or "Rejoice, Ye Pure in Heart" by Edward Hayes Plumptre

"The Christian should be a Hallelujah from head to foot."—attributed to Augustine[162]

Nearly every feast, celebration, or wedding in ancient Palestine called for rhythm, melody, and harmony. There were chants or work songs for well diggers (Num. 21:17–18), laments for those who died in battle (2 Sam. 1:18–27).[163] With tambourines and dancing, Miriam commemorated the downfall of Pharaoh and his horsemen (Exod. 15:20–21). David calmed the fretful King Saul by playing on his lyre (1 Sam. 16:23). When Solomon's temple was dedicated, 288 Levites joined in singing (1 Chron. 25:7), accompanied by harps, lyres, and cymbals (1 Chron.

162　Quoted in "Psalm 150," *Quiet Time Bible Study* (InterVarsity, 1979).

163　Anne Kilmer and Daniel Foxvog, "Music," *The HarperCollins Bible Dictionary*, revised, edited by Paul J. Achtemeier (HarperCollins, 1996), pp. 714–17.

15:16), while 120 priests blew their trumpets (2 Chron. 5:12). Indeed, the longest "book" in the Bible, the 150 Psalms, honors God musically through the entire gamut of human emotions. Books 113–118 (called the *Hallel* or "praise psalms") are still recited during such Jewish festivals as Passover, Shavuot, and Sukkot. "O give thanks to the Lord, for he is good," goes a familiar refrain, "for his steadfast love endures forever" (Ps. 118:29 NRSV).[164]

When you're happy, every part of your body wants to express it. You are exuberance in motion, whether clapping your hands, stomping your feet, or belting out some favorite tune. "If you cannot sing like the lark and the nightingale," advised Thomas à Kempis, "sing like the raven and the frogs in the pond. They sing as God has given them to sing."[165] And should you be particularly gifted—pluck, shake, blow, or bang on some accompanying instrument. Thus mountain men pull out their harmonicas; Latin American dancers rattle their maracas; and everyday folk, like you and me, hum or pucker up our lips and whistle.

One modern movement highlighting our rhythmical nature is the ecumenical Taize community in France known for its simple canons, acclamations, responses, and litanies in assorted tongues. Many were specially composed by Jacques Berthier and follow an ostinato pattern. Easy to memorize, these can be performed in a variety of settings and have attracted a worldwide audience for pieces like "*Kyrie eleison,*" "*Veni Sancte Spiritus,*" "*Nunc dimittis,*" "In the Lord I'll Be Ever Thankful" . . .[166] After all, it is imperative, poet W. H. Auden believed, for our spirits to practice their "scales of rejoicing."[167] Such buoyancy is particularly evident in the so-called "Hymns of Thanksgiving" from the Dead Sea Scrolls:

> "I played then my harp
> With sounds of redemption,
> My lyre to joyful strains,
> Yea, I blew the pipe and flute
> In ceaseless praise."[168]

Jesus, all my bones cry out to you. Uncap my effervescence. Let my entire body serve as an instrument for your praise, pulling out all the stops.

164 Chapter 11, Reuven Hammer, *Entering Jewish Prayer* (Schocken, 1994), pp. 239–49.

165 Quoted in chapter 12, Johan Huizinga, *The Autumn of the Middle Ages*, translated by Rodney J. Payton and Ulrich Mammitzsch (University of Chicago Press, 1996), p. 314.

166 Chapter 43, Andrew Wilson-Dickson, *The Story of Christian Music* (Lion Publishing, 1992), p. 227.

167 "For the Time Being: The Flight into Egypt," *Religious Drama 1: Five Plays*, selected by Marvin Halverson (Meridian, 1960), p. 67.

168 E. Werner, "Music," *The Interpreter's Dictionary of the Bible*, edited by George A. Buttrick (Abingdon, 1962), p. 467. Cf. Chapter 18, "The Thanksgiving Hymns," Geza Vermes, *The Dead Sea Scrolls in English*, revised fourth edition (Penguin, 1995), p. 223.

"The Heart of a Child"

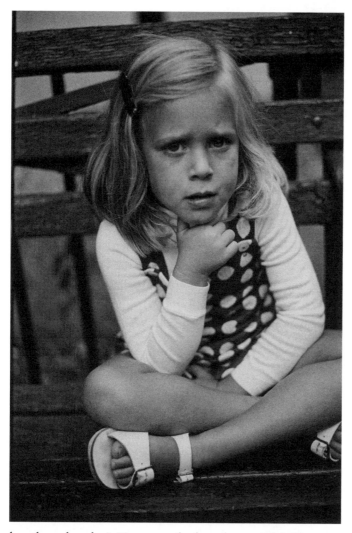

Matthew 18:1–14
"Bless'd Are the Pure in Heart" by John Keble and William John Hall

"A great man is one who has not lost the heart of a child."—Mencius.[169]

When I think of childlikeness, Saint Exupery's *The Little Prince* soon comes to mind. "Grown-ups," the narrator relates, "love figures. When you tell them that you have made a new friend, they never ask you any questions about essential matters. They never say to you, 'What does his voice sound like? What games does he love best? Does he collect butterflies?' Instead, they demand: 'How old is he? How many brothers has he? How much does he weigh? How much money does his father make?' Only from these figures do they think they have learned anything about him."

169 Section 103, "Thoughts and Epigrams," Lin Yutang, translator, *Translations from the Chinese* (World, 1963), p. 465. Cf. Book 4, Part B, section 12, *Mencius*, translated by D. C. Lau (Penguin, 1970), p. 130.

If you were to say to an adult, continues the narrator, "'I saw a beautiful house made of rosy brick, with geraniums in the windows and doves on the roof,' they would not be able to get any idea of that house at all," but suppose you said, I saw a house that cost such-and-such. "Then they would exclaim: 'Oh, what a pretty house that is!'"[170]

The honesty, the innocence, the spontaneity of children overwhelms us. If only we had their boundless energy, think how much we could accomplish. If we had their sense of curiosity, new worlds might well be within our reach. If we, too, could form friendships without considerations for class or color, earth might be an altogether different place to live.

In the fifth century B.C., Chinese philosopher Mo Tzu preached a childlike doctrine of universal love. Confucians thought one should love people in descending order—reserving the highest affection for parents and the least for those one didn't know at all. Mo Tzu, on the other hand, believed that drawing a distinction between those who are "near" and those who are "far"[171] lay at the root of our social problems. If people viewed other nations as they did their own, Mo Tzu reasoned, who would declare war? The "truly superior man," who "regards his friend

170 Chapter 4, Antoine de Saint Exupery, *The Little Prince*, translated by Katherine Woods (Harcourt, Brace & World, 1971), pp. 16–17.

171 "Mencius," Arthur Waley, *Three Ways of Thought in Ancient China* (Doubleday, 1956), pp. 129–30.

the same as himself, and his friend's father the same as his own," "will feed him when he is hungry, clothe him when he is cold, nourish him when he is sick, and bury him when he dies."[172]

Those are childlike qualities. Over time, though, we have lost the magic and elasticity of childhood. In a play by the South African Lewis Nkosi, one character explains how his son used to wake up early and "catch the rays of the sun on his small hands" and play with them; indeed, it seemed as though he were kneading his own future.[173] We all yearn for that kind of malleability and childlike sense of anticipation. "It may be," that God "has the eternal appetite of infancy;" conjectured G. K. Chesterton, but "we have sinned and grown old, and our Father is younger than we."[174]

Heavenly Father, we thank you for the wonder of childhood, for it is within the family we take our first tentative steps, inevitably fall down, then learn to pick ourselves up again, surrounded by an envelope of love. May we never despair of our incessant shortcomings, but like garden perennials keep sending out fresh and fragrant shoots.

172 Part 3, section 16, Burton Watson, translator, *Mo Tzu: Basic Writings* (Columbia University Press, 1963), pp. 40–42.

173 "The Rhythm of Violence," Act 1, Scene 1, *Plays from Black Africa*, edited by Fredric M. Litto (Hill and Wang, 1968), p. 9.

174 Chapter 4, G. K. Chesterton, *Orthodoxy* (Ignatius, 1995), p. 66.

If I Forget Zion

Psalm 137:1–6; Revelation 21:9–22:5

"Jerusalem the Golden" (*Urbs Sion aurea*) by Bernard of Cluny, translated by John Mason Neale or "Marching to Zion" by Isaac Watts, refrain by Robert Lowry

"When a man plasters his house, he should leave a small space unfinished in remembrance of Jerusalem. When a woman adorns herself with jewels, she should leave something off in remembrance of Jerusalem."—Midrash Psalm 137:6[175]

Ever since David turned an ancient Jebusite stronghold into the capital for the united monarchy (2 Sam. 5:4–7), Jerusalem has frequently been invoked in song and verse. Here Hebrew prophets confronted God's anointed and were persecuted; here Jesus rode in a triumphal procession amid cheering crowds, then found himself under sentence of death; Mohammed visited here during his famous "Night

175 "The Third Gate," Reuven Hammer, editor, *The Jerusalem Anthology: A Literary Guide* (Jewish Publication Society, 1995), p. 138. Cf. part 1, chapter 10, section 21, Hayim Nahman Bialik and Yehoshua Hana Ravnitsky, editors, *The Book of Legends: Sefer Ha-Aggadah*, translated by William G. Braude (Schocken, 1992), p. 198.

Journey," before ascending to heaven on a winged steed.[176] Images of fact and fancy mingle and merge as pilgrim-visitors record their vivid and jumbled impressions.

"O Zion, will you not ask how your captives are—the exiles who seek your welfare, who are the remnant of your flocks?" medieval Jewish poet Judah Halevi wondered aloud in one of the most moving tributes ever given to the city. "I am like a jackal when I weep for your affliction; but when I dream of your exiles' return, I am a lute for your songs." Halevi is anxious to wander in those places where God has revealed himself to his forebears. If I had wings, he says, I would carry pieces of my broken heart to its mountains. Too, he would fall upon his face, pitying the very dust, moan at the graves of his ancestors. How joyous it would be, he adds, to saunter barefoot among these sacred, desolate ruins—noting, how happy are those eager to see Jerusalem's glory once more.[177]

Jerusalem is both that earthly city filled with old covenant ghosts as well as our true celestial home, the lodestar of our brightest dreams. The threads from the old and new testaments are so inextricably interwoven that we can exclaim with eighteenth-century Methodist preacher, Thomas Olivers: "Hail, Abraham's God— and *mine*."[178] Those streets, which were bloodied by medieval crusaders, will one day be the airy habitation of saints striding in light.

The seventeenth-century physician Thomas Browne called humankind "amphibiums," since we live in two realms—one corporeal, the other ethereal; one visible, the other beyond all sensory perception.[179] Just as the larvae of toads, frogs, and salamanders are born in water and breathe through gills, then as adults develop lungs to walk on land; so we, born of flesh and of spirit (John 3:6), reside on terra firma, yet our destiny is the stars. We partake of the here-and-now, but soon we will experience what-is-yet-to-be-revealed (1 John 3:2). Then those rigid boundaries between "real" and "fantasy" will appear vaporous, paper–thin.

New Jerusalem, you are crystalline beauty itself, with your streets of sheer gold, walls of jasper, gates formed of pearl—all resting upon a foundation of exquisite gems. We long to bask in your healing glow, bathe in your sparkling fountains, breath your pristine air, taste of your ever-bearing fruit. That lantern who rules you, so wondrous to behold, is the blameless, unchangeable lamb.

176 Chapter 5, F. E. Peters, *Jerusalem* (Princeton University Press, 1985), pp. 182–85.

177 "Ode to Zion," T. Carmi, translator and editor, *The Penguin Book of Hebrew Verse* (Penguin, 1981), pp. 347–48.

178 "The God of Abrah'm Praise," twelfth stanza, Ian Bradley, editor, *The Book of Hymns* (Overlook Press, 1989), p. 406. Olivers' hymn is loosely based on the Yigdal, a metrical paraphrase of the thirteen articles of Judaism by Maimonides.

179 *Religio Medici*, first part, section 34, *The Prose of Sir Thomas Browne*, edited by Norman J. Endicott (Norton, 1972), pp. 41–42.

Imagining Eternity

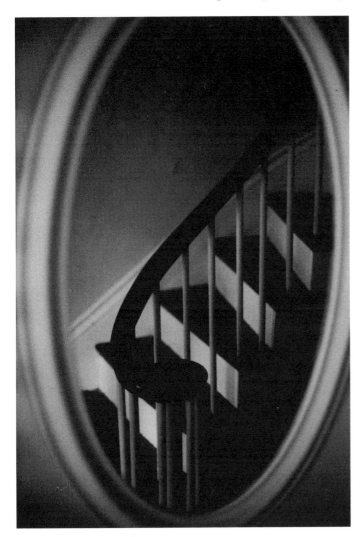

Revelation 4:1–11
"Amazing Grace" by John Newton, with additional verse by John Rees

"But if the present were always present, and would not pass into the past, it would no longer be time, but eternity."—Augustine[180]

Can you imagine eternity? Eighteenth-century French poet Antoine-Leonard Thomas compared eternity to an ocean, where "time will be engulfed like a tiny stream."[181] Historic time is minuscule compared to geological time and geological time is paltry compared to cosmic time. But in eternity, according to classical theism, there will be no chronological markers (e.g., past, present, and future—except perhaps in memory), just a constant now, *nunc stans*.[182] "High up

180 Book 11, chapter 14, John K. Ryan, translator, *The Confessions of St. Augustine* (Image, 1960), p. 288.

181 "Ode on Time," Geoffrey Brereton, editor and translator, *The Penguin Book of French Verse: Sixteenth to Eighteenth Centuries* (Penguin, 1958), p. 279.

182 John Marsh, "Eternity and Time," *A Handbook of Christian Theology*, edited by Marvin Halverson and Arthur A. Cohen (Meridian, 1972), p. 107. Cf. Book 5, section 6, Anicius

in the vault of the church hung the clock face of Eternity," remarked the German romantic Jean Paul, "on which there were no numbers."[183] "[I]n eternity," essayist Thomas Browne supposed, there will be "no distinction of Tenses."[184]

However, heaven won't be static like some still-life painting, nor will we monotonously recite the same hymns over and over in exactly the same key, a view which so discomfited poet Wallace Stevens in "Sunday Morning":

"Is there no change of death in paradise?
Does ripe fruit never fall? Or do the boughs
Hang always heavy in that perfect sky,
Unchanging, yet so like our perishing earth."[185]

Stability doesn't mean inertia, for in heaven we will continue to grow in grace and knowledge, learning to hope and trust in God more. Our thirsting will be satisfied, affirms Cappadocian father Gregory of Nyssa, yet having been satisfied, we

Boethius, *The Consolation of Philosophy* revised, translated by Victor Watts (Penguin, 1999), p. 133.

183 *Siebenkas*, translated by Sharon Jackiw, *The German Mind of the Nineteenth Century*, edited by Hermann Glaser (Continuum, 1981), pp. 29–31.
184 *Religio Medici*, first part, section 11, *The Prose of Sir Thomas Browne*, edited by Norman J. Endicott (Norton, 1972), pp. 16–17.
185 "Sunday Morning," stanza VI, Wallace Stevens, *The Collected Poems* (Vintage, 1982), p. 69.

shall thirst still more.[186] British novelist Evelyn Waugh once compared conversion to "stepping across the chimney piece out of a Looking-glass World, where everything is an absurd caricature, into the real world God made; & then begins the delicious process of exploring it limitlessly."[187] As new horizons open up, our capacity to absorb them expands.[188] So, heaven will be a land of ongoing enchantment (Ps. 16:11).

How are we to comprehend the vastness of eternity? Historian Hendrik Willem van Loon offered this analogy: "High up in the North, in the land called Svithjod, there stands a rock. It is a hundred miles high and a hundred miles wide. Once every thousand years a little bird comes to this rock to sharpen its beak. When the rock has thus been worn away, then a single day of eternity will have gone by."[189] Yet even this illustration breaks down, for one cannot quantify timelessness.

May we enter "into that gate" and dwell "in that house," "where there shall be no Cloud nor Sun, no darkenesse nor dazling, but one equall light, no noyse nor silence, but one equall musick, no fears nor hopes, but one equal possession, no foes nor friends, but one equall communion and Identity, no ends nor beginnings, but one equall eternity."—John Donne[190]

186 "Introduction" and "Eternal Progress," sections 225–26, 238–39, Gregory of Nyssa, *The Life of Moses*, translated by Abraham J. Malherbe and Everett Ferguson (Paulist, 1978), pp. 12–13, 113, 116.

187 August 6, 1949 letter in chapter 12, Michael de-la-Noy, *Eddy: The Life of Edward Sackville-West* (Bodley Head, 1988), pp. 237–38.

188 Chapter 6, J. Warren Smith, *Passion and Paradise: Human and Divine Emotion in the Thought of Gregory of Nyssa* (Herder & Herder, 2004), pp. 178–82.

189 Chapter 1, Hendrik Willem van Loon, *The Story of Mankind*, updated version (Liveright, 1972), p. 2.

190 Sermon No. 7, Evelyn M. Simpson and George R. Potter, editors, *The Sermons of John Donne*, volume VIII (University of California Press, 1956), p. 191.

An Impoverished Imagination

Psalm 96

"Come, Holy Ghost, Our Souls Inspire" (*Veni, creator Spiritus*) attributed to Rabanus Maurus, translated by John Cosin

"Art is a lie that makes us realize truth."—Pablo Picasso[191]

That human beings admire and adore what is beautiful can be seen as far back as Paleolithic times, when hunters decorated the walls and ceilings of their caves with colorful likenesses of animals.[192] Christians, however, have not always reacted favorably to the arts. Tertullian, in the late second century, claimed that believers should "have nothing to say or see or hear in connection with the frenzy of the circus, the shamelessness of the theatre, the cruelty of the arena, and the folly of

191 "Two Statements by Picasso: 1923," Dore Ashton, editor, *Picasso on Art: A Selection of His Views* (Penguin, 1980), p. 3.

192 P. P. Kahane, *Ancient and Classical Art*, translated by Robert Erich Wolff, edited by Hans L. C. Jaffe (Dell, 1968), pp. 18–23. Originally in volume 1 of *20,000 Years of World Painting*.

the gymnasium."[193] The iconoclasm controversy, which embroiled Eastern Orthodoxy during the eighth and ninth centuries, resulted in the destruction of countless paintings and mosaics. In the middle ages Cistercians aspired to "follow, naked, the naked Christ," allowing "that nothing savoring of pride or superfluity should be left in God's house."[194] In the height of religious zeal Puritans smashed organs and broke stained glass windows.

Realism was thought to be risqué, too upsetting to the soul, and fantasy considered too outlandish. On occasion, believers have been as caustic as that medieval scribe, who upon finishing the old Irish epic *Tain*, lamented: "I who have copied down this story, or more accurately fantasy, do not credit the details. . . . Some things in it are devilish lies, and some are poetical figments; some seem possible and others not; some are for the enjoyment of idiots."[195] However, in our day it is via fantasy that George MacDonald, C. S. Lewis, and J. R. R. Tolkien have given moral struggles a cosmic dimension, illuminated the fairy-tale dimensions of the Christian story itself, while writers like Flannery O'Connor and Shusaku Endo have rubbed our noses in the harsh, violent underside of reality—to shock us out of complacency.

"O sing to the Lord a new song" (Ps. 96:1 NRSV), exclaimed the Psalmist, anxious for fresh concoctions and brews. "Holy Spirit," ejaculated the 20th-century British missionary to India, Amy Carmichael, "think through me till your ideas are my ideas."[196] Who is able to read the poetry of Dante or the fiction of Dostoyevsky, gaze at the statues carved by Michelangelo or the frescoes from Fra Angelico's hand, ponder the icons of Rublev or the woodcuts of Dürer, listen to the oratorios by Handel or the Passions composed by Bach—without sensing the piety from which they sprang? Recall how, in the days of Moses, God desired Bezalel of the tribe of Judah and Oholiab of the tribe of Dan to work in gold, silver, bronze, wood, stone, and other materials to beautify the tabernacle (Ex. 31:1–11). Indeed, the sanctified imagination can be a tremendous instrument for good. Before any artist of genius, our voices ring out, "Hosanna in the highest!"

O angelic muses, the new wine simply cannot be contained within these tired, leaky skins. Therefore bend, shape, pull us in unheard-of, unfathomed directions. Loose our imaginations to invent or adapt ever more flexible fabrics and pigments. May your goodness spill over, explode into a neon mosaic of functional and ornamental patterns.

193 *Apology* 38:4, Roland H. Bainton, editor, *Early Christianity* (Van Nostrand Reinhold, 1960), pp. 120–21.

194 Quoted in chapter 16, G. G. Coulton, *The Fate of Medieval Art in the Renaissance and Reformation* (Harper & Brothers, 1958), p. 330. Cf. Letter 52, section 5, F. A. Wright, translator, *Select Letters of St. Jerome* (William Heinemann, 1933), p. 201.

195 Chapter 6, Thomas Cahill, *How the Irish Saved Civilization* (Doubleday, 1996), p. 160.

196 Chapter 7, *The Complete Book of Christian Prayer* (Continuum, 2000), p. 236.

The Incarnation—"Voiceless as Fish"

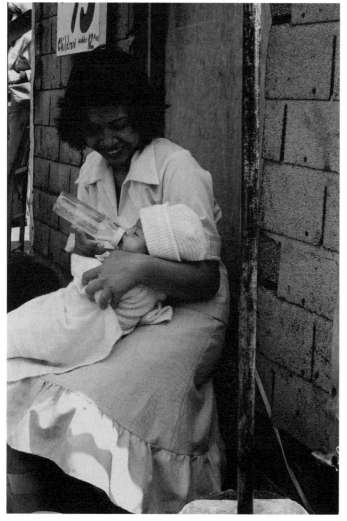

Matthew 1:18–25; Luke 1:26–38

"What Child Is This" by William Chatterton Dix or "Hark! the Herald Angels Sing" by Charles Wesley, revised by George Whitefield and others

"[T]he Word disguised himself by appearing in a body, that he might, as man, transfer men to himself, and center their senses on himself."—Athanasius[197]

Science fiction is haunted by the question of whether there is intelligent life elsewhere in the universe, and if so, how we might communicate with it. Which medium is best suited for interspecies dialogue: gestures? telepathy? mathematical formulas? hieroglyphs? Since we don't know whom or what we're looking for, it's anyone's guess. Even now antennae are trained on the heavens, hoping to detect some non-random sequence which would indicate that we are not alone.

197 "On the Incarnation," section 16, Henry Wace and Philip Schaff, editors, *Nicene and Post-Nicene Fathers*, series 2, volume 4 (Christian Literature Company, 1892), pp. 44–45.

Similarly, religions face the dilemma of how to bridge the chasm between God and man. Hindu tradition speaks of ten avatars of Vishnu, each of which rescued the world from peril.[198] In earliest times Vishnu came in an animal form; later he took on the appearance of a human being. Thus, for instance, the fish (Matsya) saved Manu from a universal flood; the tortoise (Kurma) helped to obtain the nectar of immortality; the dwarf (Vamana) reclaimed the world from the demon Bali; Rama-with-the-Axe destroyed the threat from the Kshatriya class; finally, at the end of our age Kalki will overcome barbarian kings and restore the priestly order.[199]

But an incarnation of the Holy One of Israel is a true stumbling block, almost inconceivable. At Sinai God's majesty was so overwhelming that if so much as an animal touched the mountain it had to be destroyed (Exod. 19:12–13). Even Moses, that Old Testament hero par excellence, who was entrusted with the whole house of Israel (Num. 12:6–8), was permitted to glimpse only God's "back," while safely hidden within the cleft of a rock (Exod. 33:17–23). Indeed, Yahweh may be construed as that being of whom we should always stand in awe (Ps. 33:8).

That the Virgin Mary gave birth to a baby boy who was called Jesus, since he would save his people from their sins (Matt. 1:20–23), is something the whole world should shout about (Luke. 2:10–14). Our lips stutter and stammer, language itself fumbles before such an incredible event. "Before you, mother of God," notes the Orthodox hymn to the Theotokos, "we see wordy orators as voiceless as fish."[200] The Lord of the universe didn't shout to us earthlings via a cosmic alphorn, but whispered through a newborn child. Pieter Bruegel the Elder's painting "Census at Bethlehem" draws attention to how inconspicuous was God's act. It is late on a winter afternoon; a crowd is jostling about the Green Wreath Inn in order to register and pay their taxes. There, amid the hubbub, nearly lost beside several large snow-covered barrels, is Joseph, leading a pregnant Mary on a donkey. But no one seems to notice or care.[201]

"The deed
Is done

198 Chapter 4, verses 1–8, Swami Prabhavananda and Christopher Isherwood, translators, *The Song of God: Bhagavad-Gita* (New American Library, 1951), p. 50. Here Krishna enunciates the principle of descent.

199 N. J. Hein, "Avatar, Avatara," *Abingdon Dictionary of Living Religions*, edited by Keith Crim (Abingdon, 1981), p. 82.

200 "The Akathistos Hymn," Constantine A. Trypanis, editor and translator, *The Penguin Book of Greek Verse* (Penguin, 1979), p. 384.

201 Chapter 8, Helen de Borchgrave, *A Journey into Christian Art* (Fortress, 2000), pp. 146–47.

The beautiful
Virgin
Had the Son promised by heaven:
Let us sing, Noel, Noel, Noel."—Clement Marot[202]

202 "Pastoral," chapter 2, Pegram Johnson III and Edna M. Troiano, editors, *The Roads from Bethlehem* (Westminster/John Knox, 1993), p. 87. Cf. "*Chanson Vingtcinquiesme du Jour de Noel*," Clement Marot, *Oeuvres Poetiques Completes*, tome 1 (Classiques Garnier, 1990), p. 192.

Labor with Your Own Hands

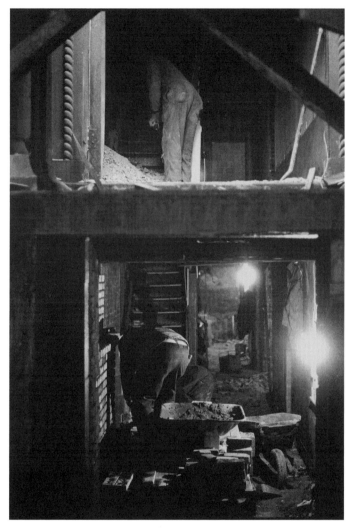

Luke 5:1–11

"God, That Madest Earth and Heaven" by J. Reginald Heber and Frederick Lucian Hosmer or "Teach Me, My God and King" by George Herbert

"No race can prosper till it learns that there is as much dignity in tilling a field as in writing a poem."—Booker T. Washington[203]

The leading occupation among those called as disciples of Jesus was fishing. Fishermen would row or sail onto the Sea of Galilee (actually a fresh-water lake), then let down their nets. Among the techniques mentioned in Scripture are the seine, the gill-net, the cast net, and the hook-and-line.[204] Hours were long, work could be lonely and back-breaking, the weather unpredictable. Once hauled onto shore, the fish had to be sorted—say, by size, species, or price—

203 "The Atlanta Exposition Address (1895)," Fred Lee Hord and Jonathan Scott Lee, editors, *I Am Because We Are: Readings in Black Philosophy* (University of Massachusetts Press, 1995), p. 244.

204 "The Fish of Galilee," "Abundance and Scarcity," Irene Martin, *Sea Fire: Tales of Jesus and Fishing* (Crossroad, 2003), pp. 56–57, 69.

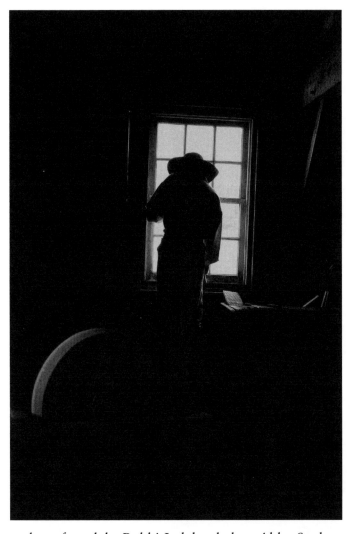

and then cleaned. Fish which were kosher, according to the Levitical code, should have fins and scales (Lev. 11:9–12); thus carp and musht pass the test, while catfish were either thrown back or sold to Gentiles. Any fish not immediately purchased would likely be slit open, salted, and hung up on a rope to dry.[205]

Ancient Judaism, having a healthy respect for manual labor, refused to separate the intellectual from the practical. According to tradition, Rabbi Akiba collected bundles of wood and sold them; Rabbi Joshua was a charcoal-burner; Rabbi Jose b. Chalaphta a worker in leather; Rabbi Jochanan a maker of sandals; Rabbi Judah a baker; Abba Saul a grave-digger.[206] Indeed, the rules of Benedict and of Augustine, which have governed Christian monastic communities for centuries, prescribe that monks should work with their hands a specified number of hours each day.[207] How different this is from that apparent disdain for menial employment found in such ancient authors as Plato or Zeno,[208] or

205 Part 3, "The Industrial Life," Madeleine S. and J. Lane Miller, *Harper's Encyclopedia of Bible Life*, third revised edition (Harper & Row, 1978), p. 384.

206 Chapter 6, section 2, A. Cohen, *Everyman's Talmud* (Schocken, 1978), p. 194.

207 Chapter 2, "Communal Labor," "*Ordo Monasterii 3*," Augustine of Hippo, *The Monastic Rules*, translated and notes by Agatha Mary and Gerald Bonner, edited by Boniface Ramsey (New City, 2004), pp. 80–83, 106–07. Cf. Rule of Benedict, section 48.

208 Chapter 4, Robert M. Grant, *Early Christianity and Society* (Harper & Row, 1977), pp. 73–74. Cf. Plato, *Republic*, 9:590C and Zeno quotation in Origen, *Contra Celsum*, 1:5.

among modern counterparts who adhere to a "gentlemanly" code of ethics which frowns on soiling one's hands!

Vincent van Gogh, in an early masterpiece known as "The Potato Eaters," depicted a family crowded around a small table, pouring tea and eating steamed potatoes—under the glow of an oil-lamp.[209] He wrote to his brother, Theo, that the piece "suggests *manual labor* and—a meal honestly earned," since the family is eating "with the self-same hands" with which they had "dug the earth." Vincent hoped that the piece would be seen as a "genuine peasant painting" in all its "coarseness," rather than a sentimental idealization.[210] In God's eyes, the peasant should be as pleased with what he has accomplished as the scholar; for it is workers like these, insists Ecclesiasticus, which "maintain the fabric of the world" (38:34 NRSV).[211]

Rescue us, o son of a carpenter, from that two-tier Christianity which discriminates based on type of occupation—whether white-collar or blue, self-employed or employee, laborer in a clean environment vs. one which is filthy. We know every honest form of work can bring you glory, if we mean it to.

209 Chapter 3, Kathleen Powers Erickson, *At Eternity's Gate: The Spiritual Vision of Vincent van Gogh* (Eerdmans, 1998), p. 88.

210 Letter 404, c. April 30, 1885, Ronald de Leeuw, editor, *The Letters of Vincent Van Gogh*, translated by Arnold Pomerans (Allen Lane, 1996), p. 291.

211 The Apocryphal/Deuterocanonical Books, *The New Oxford Annotated Bible with the Apocrypha* (NRSV), revised and enlarged, edited by Bruce M. Metzger and Roland E. Murphy (Oxford University Press, 1991), p. 140.

Lies: Breaking the Bond of Trust

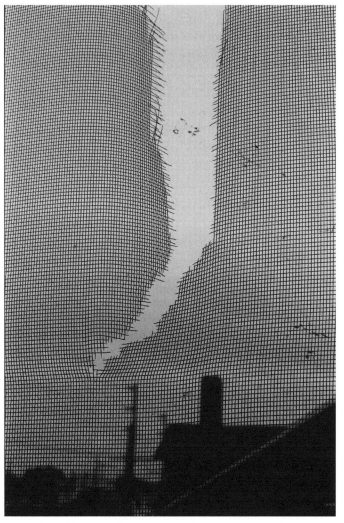

John 8:31–47
"Breathe on Me, Breath of God" by Edwin Hatch

"Resolved, in narrations never to speak anything but the pure and simple verity."—Jonathan Edwards[212]

When you lie, you create a seed of doubt. You break that bond of trust which makes communication and transactions possible. To a question raised by Consentius as to whether he should infiltrate the renegade Priscillianist community in order to expose them, Augustine replied no; it was not right to lie to heretics, even if they do perjure themselves by denying their beliefs. How can we expect to convince others of error, if we, ourselves, don't tell the truth?[213] I've found that people will lie because they are frightened, because they don't want others to judge them, because they are anxious

212 "Resolutions (1722)," no. 34, John E. Smith, Harry S. Stout, and Kenneth P. Minkema, editors, *A Jonathan Edwards Reader* (Yale University Press, 1995), p. 277.

213 Chapter 9, Sissela Bok, *Against Lying: Moral Choice in Public and Private Life* (Vintage, 1979), pp. 131–32. Cf. "Lying," chapters 1–3, Augustine, *Treatises on Various Subjects*, edited by Roy J. Deferrari (Catholic University of America Press, 1965), pp. 125–33.

to avoid a certain subject, because they seek to commit some fraud. . . . But, as the saying goes, a man is only as good as his word, which the upright will keep even to his hurt.

The fourteenth-century Japanese Buddhist priest Kenko describes the age-old reactions to lies: "If, for example, a certain man invents falsehoods and spreads them with the intent of deceit, some people will innocently suppose that he speaks the truth and be hoodwinked by his words; others will be so deeply convinced that they will think up an annoying variety of lies to add to the original one. Still others, unimpressed by the lie, will pay it no attention. Yet others will be rather suspicious and ponder over the story, neither believing nor disbelieving. Others, though they find the lie improbable, will nevertheless decide it may be true, if only because people are spreading it, and let the matter go at that."[214]

"Truth has no need of a large vocabulary,"[215] goes an old Russian proverb. It's only when we are anxious to deceive that we need a good memory, since we forget what we've fabricated, and under cross-examination, become entangled in a web we ourselves created. Augustine, on the other hand, was so committed to telling the truth that late in life he re-examined all of his 200+ "books" in *Reconsiderations*. He explained the circumstances of his writing; pointed out what he considered significant; corrected what was inappropriate or inaccurate; displayed how his mind had changed. No other author in the ancient world examined his earlier writings with such searching scrutiny.[216] If only we all could be so acutely self-aware.

"Almighty God, who hast sent the spirit of truth unto us to guide us into all truth, so rule our lives by thy power, that we may be truthful in word, and deed, and thought. O keep us, most merciful Saviour, with thy gracious protection, that no fear or hope may ever make us false in act or speech. Cast out from us whatsoever loveth or maketh a lie, and bring us all into the perfect freedom of thy truth: through Jesus Christ, thy son, our Lord. Amen."—Brooke Foss Westcott[217]

214 Section 194, Donald Keene, translator, *Essays in Idleness: The Tsurezuregusa* of Kenko, (Columbia University Press, 1967), pp. 165–66.

215 Catherine II, "Choice Russian Proverbs," *The Portable Russian Reader*, translated by Bernard Guilbert Guerney (Viking, 1961), p. 636.

216 Allan D. Fitzgerald, "*Retractationes*," Allan D. Fitzgerald, general editor, *Augustine Through the Ages: An Encyclopedia* (Eerdmans, 1999), pp. 723–24. Cf. Augustine, *The Retractions*, translated by Mary Inez Bogan (Catholic University of America Press, 1968).

217 "Collect for Truthfulness," Brooke Foss Westcott, *Common Prayers for Family Use* (Macmillan and Co., 1903), p. 17.

Lions vs. Doves

Matthew 10:16–22

"Make Me a Channel of Your Peace" by Sebastian Temple

"The spiritual virtue of a sacrament is like light—although it passes among the impure, it is not polluted."—Augustine[218]

In a world where persecution is never far away, Jesus warned his disciples to "be wise as serpents and innocent as doves" (Matt. 10:16 NRSV). They should testify of him, but also be savvy about the potential for danger and never lose their sense of integrity. Paul in the same spirit advised the Christians at Rome, "I want you to be wise in what is good and guileless in what is evil" (Rom. 16:19 NRSV). Images of doves, representing gentleness and purity, were common in the catacombs and appeared on early Christian tombs, ritual vessels, and lamps.[219] To be

218 Christopher Morley, editor, *The Shorter Bartlett's Familiar Quotations* (Pocket Books, 1964), p. 14. Cf. Tractate 5, section 15, Augustine, *Tractates on the Gospel of John 1–10*, translated by John W. Rettig (Catholic University of America Press, 1988), p. 123.

219 Part 4, "The Dove and the Raven," Louis Charbonneau-Lassay, *The Bestiary of Christ*, translated and abridged by D. M. Dooling (Arkana, 1992), p. 231. Cf. "Doves and Pigeons," Hans

good, Jesus recognized, does not mean one should be naive; rather, he coupled simplicity with shrewdness.

What a striking contrast between Jesus's maxim and that of Renaissance political thinker Niccolo Machiavelli. Machiavelli chose two quite different animals to admire in his manual for rulers, namely the lion and the fox: "[F]or the lion cannot defend itself from traps and the fox cannot protect itself from wolves. It is therefore necessary to be a fox in order to recognize the traps and a lion in order to frighten the wolves."[220] The fox for Machiavelli had few scruples, other than knowing how to keep on top. (As British Lord Chancellor Francis Bacon, whose ambition would prove his own comeuppance, once confessed, "All rising to great place is by a winding stair.")[221] And it goes without saying that lions and doves are on opposite ends of the predator-prey scale. In *The Discourses* Machiavelli taught, "[I]t is enough to ask for a man's weapons without saying, 'I wish to kill you with these.' When you have the weapon in hand, then you can satisfy your desire."[222] Comments like these led contemporary Florentine historian Guicciardini to reprimand Machiavelli for his cruelty.[223]

Machiavelli's cynicism is hard to miss: "And men are less hesitant about harming someone who makes himself loved than one who makes himself feared because love is held together by a chain of obligation which, since men are a sorry lot, is broken on every occasion in which their own self-interest is concerned; but fear is held together by a dread of punishment which will never abandon you."[224] In rejecting such worldly tactics and motives, Jesus urged his disciples to not act like Gentile despots (who lord it over their subjects), but to be servants one of another (Luke 22:24–27). While fear may compel obedience for a season, it is sincerity and good-will which commands allegiance long-term. Even Friedrich Nietzsche, that nineteenth-century exponent of the *Übermensch*, acknowledged, "Thoughts that come on doves' feet guide the world."[225]

O unsullied savior, enable us to put away all hurtful behavior, purging our hearts of the thorns of malice and deceit, whatever lusts that would lead us down the path of perdition. May we be as wily as serpents in recognizing evil, yet as innocent as doves in putting goodness into practice.

Biedermann, *Dictionary of Symbolism*, translated by James Hulbert (Facts on File, 1992), p. 101.

220 Chapter 18, *The Prince*, Peter Bondanella and Mark Musa, editors and translators, *The Portable Machiavelli* (Penguin, 1979), p. 134.

221 "Of Great Place," *The Essayes or Counsels* (1625), Sidney Warhaft, editor, *Francis Bacon: A Selection of His Works* (Odyssey Press, 1965), p. 73.

222 Book 1, chapter 44, *The Discourses*, Bondanella and Musa, eds., *Portable Machiavelli*, p. 262.

223 Part 3, chapter 1, Herbert Butterfield, *The Statecraft of Machiavelli* (Collier, 1962), p. 74.

224 Chapter 17, Bondanella and Musa, eds., *The Prince*, p. 131.

225 *Thus Spoke Zarathustra*, Second Part, "The Stillest Hour," Walter Kaufmann, editor and translator, *The Portable Nietzsche* (Penguin, 1984), p. 258.

The Magnetic Cross

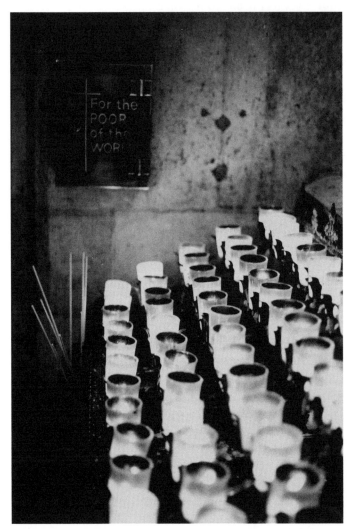

John 12:20–36

"O Sacred Head, Sore Wounded" (*Salve caput cruentatum*) anonymous, translated by Robert Bridges or "What Wondrous Love Is This" (American folk hymn)

"I flee the cross which devours me, I cannot bear its heat."—Jacopone da Todi[226]

Jesus' death on the cross has atoned for the sins of the whole world (1 John 2:2). He draws a cross-section of all humanity (Rev. 7:9) toward his magnetic pole (John 12:32–33). As a child I was astonished by the way magnets could pick up objects without actually touching them. So powerful was their pull that paper clips and iron filings would come flying across empty space. This property seemed almost magical.[227] In much the same way, those who preach Christ's sacrificial death in remote corners of the globe have, on occasion, been startled by tremendous movements of the Spirit.

226 "Of the Various Ways of Contemplating the Cross," George R. Kay, editor and translator, *The Penguin Book of Italian Verse* (Penguin, 1958), p. 3.

227 Chapter 1, James D. Livingston, *Driving Force: The Natural History of Magnets* (Harvard University Press, 1996), pp. 2–3.

Crucifixion was a wrenching form of punishment which the Romans largely reserved for slaves, the lower classes, violent rebels, soldiers, and those who committed treason.[228] To think that God would voluntarily undergo such horrific torture in order to redeem an estranged race of insurgents makes our mouths stop (Rom 5:6–10). The more we ponder God's immense compassion though, the more eagerly we want to reciprocate. "Yet everyone becomes more righteous—by which we mean a greater lover of the Lord—after the passion of Christ than before," states medieval philosopher Peter Abelard, "since a realized gift inspires greater love than one which is only hoped for."[229]

It is not surprising then that the first exercise of the first week in Ignatius of Loyola's *The Spiritual Exercises* reads: "Imagine Christ our Lord suspended on the cross before you, and converse with him in a colloquy: How is it that he, although he is the Creator, has come to make himself a human being? How is it that he has passed from eternal life to death here in time, and to die in this way for my sins?" Then Ignatius draws the personal application: "In a similar way, reflect on yourself and ask: What have I done for Christ? What am I doing for Christ? What ought I to do for Christ? In this way, too, gazing on him in so pitiful a state as he hangs on the cross, speak out whatever comes to your mind."[230]

Christ has turned the ancient world's equivalent of the electric chair, or gallows, into a revelation of hope. That most despised, most shameful form of Roman execution has become the emblem of our salvation. An early Christian insignia shaped in the form of a cross ingeniously depicted this reversal; three letters of the Greek alphabet (*phos* or light), aligned vertically, intersect three letters (*zoe* or life) aligned horizontally, with a common omega at the center. So, at the very sign of death, light and life triumph.[231] Now that's a magnetic cross!

> "Amazing love! How can it be
> That thou, my God, shouldst die for me?"—Charles Wesley[232]

228 Chapter 1, Gerard S. Sloyan, *The Crucifixion of Jesus* (Fortress, 1995), p. 18. Cf. Martin Hengel, *Crucifixion*, translated by John Bowden (Fortress, 1977).

229 Peter Abelard, "On Romans 3:19–26," translated by Gerald E. Moffatt, *A Scholastic Miscellany: Anselm to Ockham*, edited by Eugene R. Fairweather (Macmillan, 1970), p. 284.

230 "The First Exercise," George E. Ganss, editor, *Ignatius of Loyola: The Spiritual Exercises and Selected Works* (Paulist, 1991), p. 138.

231 Chapter 5, Margaret Visser, *The Geometry of Love* (North Point, 2000), p. 124.

232 "And can it be that I should gain," Frank Whaling, editor, *John and Charles Wesley: Selected Writings and Hymns* (Paulist, 1981), p. 197.

Our Life, a Mere Vapor

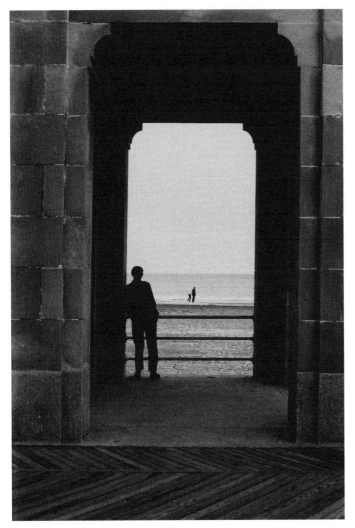

Psalm 90:1–12

"O God, Our Help in Ages Past" by Isaac Watts (based on Psalm 90) or "Brief Life Is Here Our Portion" (*Hic Breve Vivitur*) by Bernard of Cluny, translated by John Mason Neale

"Stop and consider! Life is but a day;

A fragile dew-drop on its perilous way

From a tree's summit."—John Keats[233]

Our time on earth is short, maybe 70–80 years. Where we've come from is shrouded in mystery and where we are going is in bitter dispute. "In the life of a man, his time is but a moment," opined Roman emperor/Stoic philosopher Marcus Aurelius, "his being an incessant flux, his senses a dim rushlight, his body a prey of worms, his soul an unquiet eddy, his fortune dark, and his fame doubtful. In short, all that is of the body is as coursing waters, all that is of the soul as dreams

233 "Sleep and Poetry," lines 85–87, Miriam Allott, editor, *Keats: The Complete Poems* (Longman, 1975), pp. 72–73.

and vapors; life a warfare, a brief sojourning in an alien land; and after repute, oblivion."[234]

"My days," complained that Old Testament hero Job, "are swifter than a weaver's shuttle" (Job 7:6 NRSV). We are born, attend school, choose a vocation, raise a family, and then it's nearly time to start winding down. The telltale signs of aging are plain enough for all to see: "gray hairs, rotten teeth, dim eyes, trembling joints, short breath," enumerates seventeenth-century devotional writer Jeremy Taylor, "stiff limbs, wrinkled skin, short memory, decayed appetite."[235]

Of the eons since the universe began and the eons till it ceases, we've been allotted but a tiny fraction, and that flies by so quickly we're never quite sure what happened or how. Oh, to be sure, we may have racked up a few flimsy achievements, but we've also been caught up in so many activities that now just don't seem worth the bother. Our lot as human beings, thought German philosopher Arthur Schopenhauer, is to "blow out a soap-bubble as long and as large as possible, although we know perfectly well that it will burst."[236] While some actions, no doubt, will mutate into new, more exalted forms; others, alas, will soon disappear.

Meantime death, like a sword of Damocles, hangs poised above us. Who knows when noonday will be turned to night? Men are given a clean bill of health in the morning and drop dead by evening. During the lavish dinner party held by Trimalchio in Petronius's *The Satyricon*, a slave brings in a silver skeleton. It was "put together in such a way that its joints and backbone could be pulled out and twisted in all directions." Flinging "it about on the table once or twice, its flexible joints falling into various postures," Trimalchio proceeded to declaim to all the gathered revelers on how short was life's span.[237]

"Alas, where have all my years gone to? Has my life been just a dream, or is it real? And all those things that I used to think stood for something, did they really stand for anything? It seems as though I have been asleep without knowing it."— Walther von der Vogelweide[238]

234 Book 2, section 17, Marcus Aurelius, *Meditations*, translated by Maxwell Staniforth (Penguin, 1976), p. 51.

235 Chapter 1, *The Rule and Exercises of Holy Dying*, Thomas K. Carroll, editor, *Jeremy Taylor: Selected Works* (Paulist, 1990), p. 469.

236 *The World as Will and Idea*, book 4, section 57, DeWitt H. Parker, editor, *Schopenhauer: Selections*, translated by R. B. Haldane and J. Kemp (Charles Scribner's Sons, 1928), p. 231.

237 Chapter 15, J. P. Sullivan, translator, *Petronius: The Satyricon* and *Seneca: The Apocolocyntosis* (Penguin, 1981), p. 50.

238 "Owe war sint verswunden alliu miniu jar?" Leonard Forster, editor and translator, *The Penguin Book of German Verse* (Penguin, 1959), p. 25.

Praying Amiss

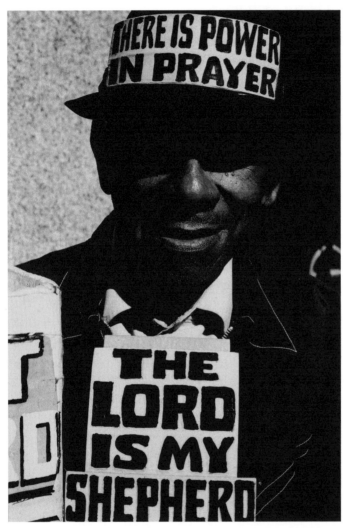

Matthew 6:5–15

"Be Thou My Vision, O Lord of My Heart" (*Rob tu mo bhoile, a Comdi cride*) anonymous, translated by Mary Byrne, formed into verse by Eleanor Hull

"God is not a cosmic bell-boy for whom we can press a button to get things."—Harry Emerson Fosdick[239]

In prayer sincerity is not enough; we must remember who God is and who we are. A wonderful parody of our typical petitions can be found in W. H. Auden's drama, "For the Time Being." The fictional Herod writes tongue-in-cheek: "O God, put away justice and truth. . . . Leave Thy heavens and come down to our earth of waterclocks and hedges. Become our uncle. Look after Baby, amuse Grandfather, escort Madam to the Opera, help Willy with his home-work, introduce Muriel to a handsome naval officer." In short, "[b]e interesting and weak like us, and we will love you as we love ourselves."[240]

239 "Prayer," Frank S. Mead, editor, *The Encyclopedia of Religious Quotations* (Pillar Books, 1976), p. 508.
240 "The Massacre of the Innocents," *Religious Drama 1: Five Plays*, selected by Marvin Halverson (Meridian, 1960), p. 59.

Another kind of misguided prayer is mentioned by anthropologist Marvin Harris in his study of a small county seat in Brazil: "A man whose wife is sick . . . prays to his favorite saint:. . . . 'Grant my wife health and I will set off a half-dozen skyrockets in front of the main door of the church on your day.'" Harris calls this, *promessa*, "a prayer which contains a bribe." The believer's devotion, or gratitude, is contingent on God actually carrying out what's being requested.[241]

In both instances the focus is too much on God's immanence, while downplaying his awe–inspiring transcendence. We long for some tame god, a household deity who will stand by our side, rather than an omniscient ruler of the universe, the king of glory, who both disciplines and chastises. Still, I do think it appropriate to approach God as a child does a parent,[242] pouring out our concerns (the petty alongside the significant), complaining of day-to-day frustrations, boasting of mini-triumphs—since God, like any caring parent, is anxious to hear what's been happening in our lives. After all, he is "more affectionate than any friend, more just than any ruler, more loving than any father, more a part of us than our own limbs," maintains Byzantine mystic Nicholas Cabasilas, "more necessary to us than our own heart."[243]

But it would be the height of hubris to sit like some child on Santa Claus's lap with a long wish list—anxious to turn the Almighty into a free-flow dispenser for our distorted desires. Rather is God, contends C. S. Lewis, "the great iconoclast," constantly smashing false images of who he is and what he is like.[244] Too often our prayers appear manipulative and self-centered, as though God were some cosmic cheerleader for all our half–baked schemes. Remember, he is the benevolent monarch; we, at best, are reluctant, self-serving subordinates (Lk. 17:10).

"Lord, I know not what I ought to ask of you; you only know what I need; you love me better than I know how to love myself. Father, give to me, your child, that which I myself know not how to ask. . . . Behold my needs which I know not myself, and see and do according to your tender mercy. Smite, or heal, depress me, or raise me up. . . . I yield myself to you. I would have no other desire than to accomplish your will."—Francois Fenelon[245]

241 "Religion," Marvin Harris, *Town and Country in Brazil* (AMS Press, 1969), p. 223.

242 Matthew 6:9b, Ulrich Luz, *Matthew 1–7 (Hermeneia)*, translated by James E. Crouch (Fortress, 2007), pp. 314–16.

243 Quoted in chapter 1, Kallistos Ware, *The Orthodox Way*, revised (SVS Press, 1995), p. 12. Cf. Book 4, section 18, Nicholas Cabasilas, *The Life in Christ*, translated by Carmino J. deCatanzaro (SVS Press, 1998), p. 143.

244 Chapter 4, C. S. Lewis, *A Grief Observed* (Bantam, 1976), p. 76.

245 "The Seventeenth Century," Michael Counsell, compiler, *2000 Years of Prayer* (Morehouse, 1999), p. 298. Cf. "Short Meditations," Luke 11: 1, Francois de Salignac de la Mothe Fenelon, *Meditations and Devotions*, selected and translated by Elizabeth C. Fenn (Morehouse-Gorham, 1952), p. 31.

Preaching to the Birds

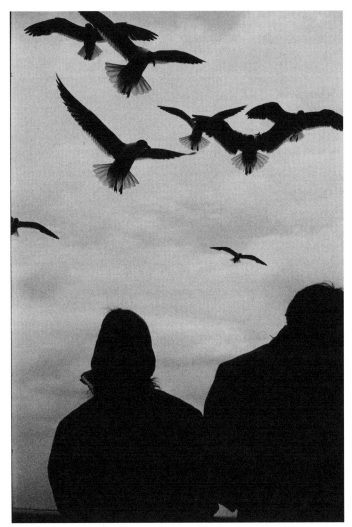

Job 38:1–8, 39–41; 39: 26–40:5

"God of the Sparrow God of the Whale" by Jaroslav J. Vajda

"All things therefore are charged . . . with God and if we know how to touch them give off sparks and take fire, yield drops and flow, ring and tell of him."—Gerard Manley Hopkins[246]

Francis of Assisi longed for kinship with all God's creation as can be seen in his delightful "Canticle of Brother Sun." Listen in to his sermon to the birds: "My brother birds, you should greatly praise your Creator, and love him always. He gave you feathers to wear, wings to fly, and whatever you need. God made you noble among his creatures and gave you a home in the purity of the air."[247] (In that same chapter Francis's biographer, Thomas of

246 "The Contemplation to Obtain Love," John Pick, editor, *A Hopkins Reader*, revised and enlarged (Image, 1966), p. 404.

247 Chapter 21, Thomas of Celano, "The Life of Saint Francis," *Francis of Assisi: Early Documents, Volume 1: The Saint*, edited by Regis J. Armstrong, J. A. Wayne Hellman, and William J. Short (New City Press, 1999), p. 234.

Celano, refers to further nature miracles concerning rabbits, fish, and swallows.)

I, too, am enamored of these feathered vertebrates. Hummingbirds fascinate me with their hovering metallic sheen; woodpeckers due to their rackety beaks; hawks from how they soar in high, lazy circles; mourning doves by their lovely coos; nuthatches from how they amusingly descend tree trunks head first; swallows because of the way they dart in and out over our heads; parrots and mynahs because of their incredible facility for mimicry; sandpipers by the way they scurry along the surf; pheasants from how they suddenly burst out of hiding; cardinals due to their flamboyant tufted heads; peacocks because of their shimmering-eye fans. . . .

These winged creatures inhabit a realm so alien from our own; they appear so fragile, yet free. Their plumage delights our eyes, their songs distract us from care, extols Capuchin friar Martial de Brives, who calls them "visible voices, feathered sounds, . . . living lutes."[248] Furthermore, the peculiar traits of one species in no way detract from any other's. Nineteenth-century Carmelite Therese of Lisieux once remarked: "I understood how all the flowers he has created are beautiful, how the splendor of the rose and the whiteness of the lily do not take away the perfume of the little violet or the delightful simplicity of the daisy."[249] Each living creature has its own radiant uniqueness.

If only I could identify each species in its setting, like artist/biologist John James Audubon, depict its peculiar habits, display its finery with my palette. Or, had I a more engineering bent like Leonardo da Vinci, then I would make sketches of my own dream flying machine. Without such obvious propensities, what I do each winter is set out a delectable mix of seeds, allowing me to nourish and view a few of these, my graceful friends.

The eighth-century scholar/librarian, Alcuin, instrumental in the Carolingian renaissance, left this anthem for his lost nightingale:

> "You lightened my sad heart from its distress,
> And flooded my whole soul with melody. . . .
> What marvel if the cherubim in heaven"
> Continually praise God, when to you,
> O tiny nightingale [your favorite bird?], such illustrious grace was
> given?[250]

248 "Paraphrase of the Song of the Three Young Men," Geoffrey Brereton, editor and translator, *The Penguin Book of French Verse: Sixteenth to Eighteenth Centuries* (Penguin, 1958), p. 227.

249 Chapter 1, John Clarke, translator, *Story of a Soul: The Autobiography of St. Therese of Lisieux* (ICS Publications, 1976), p. 14.

250 "Written for his Lost Nightingale," Helen Waddell, editor and translator, *Medieval Latin Lyrics* (Penguin, 1962), p. 99. The ending has been slightly adapted.

God of the hawk, God of the finch, unstopper our ears to savor the exuberant strains of your aviary symphony; unshutter our eyes to behold its rainbow of feathers; unloosen our tongues to join in creation's mellifluous crescendo.

A Preferential Option for the Poor[251]

Psalm 82
"Where Cross the Crowded Ways of Life" by Frank Mason North

> "For so many fall in decay. . . .
> And so many wrongfully undone,
> Saw I never."—John Skelton[252]

In the Torah there are injunctions to not forget the widow, the orphan, or the resident alien (Deut. 14:28–29). In the Book of Ruth (2:1–7) one sees how the provision to leave gleanings for the poor (Lev. 19:9–10, Deut. 24:19) was actually put into practice. Hebrew spokesmen repeatedly railed against a warped, misshapen society where the rich and powerful took advantage of the vulnerable, the marginalized, and those who had no defender. "God blesses those who come to the aid of the poor," the new Catholic catechism bluntly states, "and rebukes those

252 "The Manner of the World Nowadays," Peter Levi, editor, *The Penguin Book of English Christian Verse* (Penguin, 1984), pp. 37–38.

who turn away from them."[253]

The early church's social impetus was deeply rooted in its Old Testament heritage. At times we see early Christians caring for widows, the sick and the disabled; supporting the unemployed; aiding orphans, prisoners, and shipwrecked sailors; ransoming debtors and slaves; giving the poor a decent burial; providing food during famines, medical help during plagues.[254] Hospitals, orphanages, shelters for travelers and for the poor, granaries for distributing food, asylums for the persecuted, all were gradually established at great cultural centers.[255] Indeed, the extent of Christian charity simply astounded pagan observers in the ancient world.

"[D]id you know that men slept out all night on the bridges?" William Booth, the founder of the Salvation Army, asked his son in 1887. "Well, yes," replied Bramwell, "a lot of poor fellows, I suppose, do that." "Then you ought to be ashamed of yourself to have known it and to have done nothing for them." He responded: "What can we do?" "Get them a shelter!" "That will cost money." "Well, that is your affair!" reprimanded William. "Something must be done. Get

253 Part 3, article 7, section 6, "Love for the Poor," paragraph 2443, *Catechism of the Catholic Church* (Ignatius, 1994), p. 587.

254 Book 2, chapter 4, Adolf Harnack, *The Mission and Expansion of Christianity in the First Three Centuries*, translated and edited by James Moffatt (Peter Smith, 1972), pp. 147–98.

255 Francis X. Murphy, "Social Thought," Everett Ferguson, editor, *Encyclopedia of Early Christianity* (Garland, 1990), p. 856.

hold of a warehouse and warm it, and find something to cover them."[256] Thus was born the city shelter, one of the distinguishing marks of the Army's worldwide ministry. It is incumbent upon Christians of every era to both help needy individuals and to be engaged in meaningful reform; to show acts of kindness as well as to repair glaring breaches; to aid fallen victims plus work toward restructuring society as a whole.

"O God, those whom we, through ignorance or forgetfulness have not remembered, do thou, remember them. . . . For thou, O God, are the help of the helpless, the hope of the hopeless, the savior of the tempest-tossed, the harbor of mariners, the physician of the sick. Be yourself all things to all men, who knows each and his petition and his dwelling and his need."—Byzantine Liturgy of St. Basil.[257] Help us each to be effective agents of your love, catalysts for lasting renewal.

256 Chapter 1, Bramwell Booth, *Echoes and Memories* (George H. Doran, 1925), pp. 1–2.
257 "Occasional Prayers," Tony Castle, compiler, *The New Book of Christian Prayers* (Crossroad, 1986), p. 303. Cf. R. C. D. Jasper and G. J. Cuming, translators and editors, *Prayers of the Eucharist: Early and Reformed*, 3rd ed. revised and enlarged (Pueblo, 1987), pp. 121–22.

Racism: Stripping Myths Naked

Genesis 9:18–27; Galatians 3:19–29
"In Christ There Is No East or West" by John Oxenham

"You must do this throughout life; when things appear too enticing, strip them naked, destroy the myth which makes them proud."—Marcus Aurelius[258]

In recent centuries racism has become a particularly blatant form of prejudice—used to justify everything from the African slave trade to "Aryan" purity in Nazi Germany. An especially sorry episode is how the curse of Ham in Genesis 9:20–27 was reinterpreted to condone the mistreatment of blacks. Noah plants a vineyard, drinks too much wine, then is found naked in his tent. When he wakes up, he realizes that one of his sons (Ham) has seen him uncovered, so pronounces a curse on Ham's son, Canaan, who is to become a slave to his brothers (9:25). But no link was ever made between Canaan and

258 Book 6, section 13, Marcus Aurelius Antoninus, *The Meditations*, translated by G. M. A. Grube (Bobbs-Merrill, 1975), p. 50.

black Africans until centuries later, when it dovetailed too neatly with cultural stereotypes.[259]

Anthropologists tell us there is no scientific basis for the existence of a pure race, since even nomadic tribes have intermingled with captured women and children.[260] Instead, labels such as black/white or male/female should be regarded as adjectives for the generic noun "human."[261] From the story of Adam and Eve, we know that humanity has a common ancestry (Gen. 1:27; Acts 17:26–27); dominant groups, though, like to weave a mythology to vindicate their superior position, sanctioning oppression. Epithets like "primitive," "inferior," "barbarian" are hurled from their lips, perhaps even pseudo-scientific rationales given for their behavior, intimations of eugenics whispered. But great civilizations have risen and fallen on every continent and among all races, so any notions of superiority can only be promulgated with blinders.

The centuries-old fault lines of nationality, language, ethnic group, social class, and sex are being torn down at the cross—reconciling all believers into a new, more inclusive family. "There is no longer Jew or Greek, there is no longer slave or free, there is no longer male and female," Paul announced to the Galatians, "for all of you are one in Christ Jesus" (3:28 NRSV). When I come to church, I fully expect to meet people from widely differing backgrounds, some of whom I don't normally associate with in my insular comings and goings—much to my shame.

So this Sunday morning, should you hear a text of Scripture twisted out of context and interpreted in a self-serving manner, do as Marcus Aurelius recommends; strip naked the myth which has made it proud, so that bigotry might be swiftly refuted. Marcus wants us see things as they are, not as they presume to be. For instance, he urges us to recognize "a purple robe" as nothing more than "sheep's wool dyed with the blood of a shellfish," heady old Falernian wine as simply "the juice of a cluster of grapes."[262] Should we let a falsehood or misrepresentation go unchecked—division, strife, even violence can ensue. Recall how, partly warranted by a false mythology, the "peculiar institution" of slavery corrupted the American south[263] and the officially-sanctioned apartheid tore South Africa apart.[264]

259 "Conclusion," David M. Goldenberg, *The Curse of Ham* (Princeton University Press, 2003), pp. 195–200.

260 Chapter 2, Louis L. Synder, *The Idea of Racialism* (Van Nostrand, 1962), p. 19.

261 "Are Women Human?" "The Human-Not-Quite-Human," Dorothy L. Sayers, *A Matter of Eternity*, edited by Rosemond Kent Sprague (Eerdmans, 1973), pp. 35–37.

262 Marcus Aurelius Antoninus, *The Meditations, loc. cit.*

263 Chapter 1, Kenneth M. Stamp, *The Peculiar Institution: Slavery in the Ante-Bellum South* (Vintage, 1956) pp. 3–14.

264 In South Africa the Herenigde Party formed its apartheid mythology by appealing to verses like Deut. 32:8 and the story of the Tower of Babel—warning against two disparate groups being

"O God, who hast made of one all nations to dwell upon the earth, and who by thy Son Jesus Christ has broken down the walls of partition between Jew and Gentile, slave and free, Greek and barbarian: Break down, we beseech thee, all that divides us one from another; shame our jealousies, and lay low our pride; do away with all race-prejudice, that the bonds of fellowship and mutual service may unite the East and the West, the North and the South, that we may live in peace together, in honor preferring one another; to the glory of the thy great name."— G. C. Binyon[265]

joined together. Cf. chapter 1, Edwin M. Yamauchi, *Africa and the Bible* (Baker, 2004), pp. 31–32.

265 *"Tuesday—Thy Kingdom Come,"* Gilbert Clive Binyon, arranger, *Prayers for the City of God,* third edition (Longmans, Green and Co., 1919), p. 136.

The Ruts of Unthinking Conformity

Romans 11:33–12:2; 1 John 2:12–17
"Guide Me, O Thou Great Jehovah" (*Arglwydd, arwain trwy'r anialwch*) by
William Williams, translated and adapted by Peter Williams and William Williams

> "[O]nly that he may conforme
> To (Tyrant) Custom's, awe-les law-les Forme,
> Which bleares our eyes, and blurrs our Sences so."
> —Guillaume de Saluste, Sier du Bartas[266]

"It is remarkable how easily and insensibly we fall into a particular route, and
make a beaten track for ourselves," observed nineteenth-century Transcendentalist
Henry David Thoreau. "I had not lived" at Walden "a week before my feet wore
a path from my door to the pondside; and though it is five or six years since I trod

266 Second week, third day, part 2, "The Fathers," lines 478–80, *The Divine Weeks and Works of
Guillaume de Saluste, Sieur du Bartas*, volume 2, translated by Joshua Sylvester, edited by Susan
Synder (Oxford: Clarendon Press, 1979), p. 543.

it, it is still quite distinct. It is true, I fear, that others may have fallen into it, and so helped to keep it open. The surface of the earth is soft and impressible by the feet of men; and so with the paths which the mind travels. How worn and dusty, then, must be the highways of the world, how deep the ruts of tradition and conformity!"[267]

Reading *Walden; or, Life in the Woods* made a deep impression on my teenage mind. Perhaps it was because I had grown up on a farm and liked the great outdoors; perhaps Thoreau's sentiments seemed so sensible that I was bowled over by their logic; perhaps I admired the stark simplicity of his style, which could turn the fodder of everyday existence into poetic adages. But most likely it was Thoreau as the student of human nature which captivated me.

Like some desert hermit, Thoreau left society in order to sharpen his vision concerning what was truly "essential."[268] He took what fellow New Englander, Robert Frost, would call the road "less traveled by, / And that has made all the difference."[269] It was during his time at Walden that Thoreau refused to pay a poll tax, which became the basis for his famous essay, "On the Duty of Civil Disobedience." His writings and lifestyle questioned conventions regarding how to make a living and how to spend one's leisure time—beckoning his contemporaries to jettison what had little value.

Aristodemus said of Socrates that he was in the habit of drawing apart from his fellows and standing alone, lost in thought.[270] We, too, must figuratively distance ourselves from the world in order to ponder which customs honor or dishonor Christ, to take a stand against misguided intellectual currents (e.g., consumerism, militarism) without getting caught up in overreactions or dubious counter movements. If we aren't able to do this, we risk, during times of social upheaval, becoming what theologian H. Richard Niebuhr called Hallelujah choruses for popular fashions.[271]

The desert fathers and early monastics felt squeezed into a mold, compromised by social strictures, unable to devote sufficient time to prayer, Scripture, and worship, so they either lived alone or formed loose, self-sustaining communities based on spiritual rules. Ever since, religious orders have been in the vanguard of Christian influence around the globe. Yes, it is imperative for believers, individually and

267 Chapter 18, Henry David Thoreau, *Walden; or, Life in the Woods* (New American Library, 1960), p. 214.

268 Chapter 2, ibid., p. 66.

269 "The Road Not Taken," Robert Frost, *Complete Poems of Robert Frost* (Holt, Rinehart and Winston, 1964), p. 131.

270 *Symposium*, 175b, translated by Michael Joyce, *The Collected Dialogues of Plato*, edited by Edith Hamilton and Huntington Cairns (Princeton University Press, 1989), pp. 529–30.

271 Chapter 1, H. Richard Niebuhr, *The Social Sources of Denominationalism* (Meridian, 1964), pp. 22–23.

collectively, to work toward some transforming vision. "If you have built castles in the air," attested Thoreau, "your work need not be lost; that is where they should be. Now put the foundations under them."[272]

God in the highest, we fall so easily into the ruts of unthinking conformity, assuming our own community, nation, or age is the essence of virtue. Give us a second touch to more fully observe corrosive flaws residing within and without. Convert us through and through, lest by succumbing to passing fads and fancies, we swerve farther from your truth. Free us from the clutches of Zeitgeist conformity. Grant us an extreme makeover.

272 Chapter 18, Thoreau, *Walden*, p. 215.

Scarecrows in a Cucumber Patch

Jeremiah 10:1–12
"El Shaddai" by Michael Card and John Thompson or "Holy, Holy, Holy! Lord God Almighty" by Reginald J. Heber

"People pray to the images of the gods, implore them on bended knees, sit or stand long days before them, throw them money, and sacrifice beasts to them, so treating them with deep respect."—Seneca[273]

Idols, the classical Hebrew prophets reasoned, were little more than sticks and stones. Jeremiah compared these lifeless statues to scarecrows in a cucumber patch (Jer. 10:5). Isaiah ridiculed the way idols were produced: a cedar or an oak is cut down; one section of a log is used for cooking and another section carved into a human likeness; one portion is burnt for warmth and another portion bowed down to. How can one worship a block of wood, he taunts, since it has been fashioned by human hands and is quite obviously a fraud (44:9–20)?

273 A paraphrase based on a quote in book 2, chapter 2, Lactantius, *The Divine Institutes*, books I–VII, translated by Mary Francis McDonald (Catholic University of America Press, 1964), p. 99.

From ancient Egyptian and Mesopotamian texts we know that there was an elaborate magical ceremony which "opened" an idol's eyes, "washed" its mouth, and endowed it with "life." Once it became a suitable abode for the presence of the god, the image would be dressed in royal clothes, carried about in processions, prayed to, and offered the choicest nourishment. The temple staff then, in effect, became the idol's attendants.[274]

"Not long ago (ah, the blindness of it!) I, too, worshiped statues that came out of ovens," admitted the fourth-century church father Arnobius, "gods hammered out on an anvil, gods in elephant tusks, in paintings, streamers on aged trees. If I saw a stone stained with olive oil, I would venerate it as though a divine power was present, I would address it and ask for favors although it were merely a block without any feeling."[275] The Aztecs, quite familiar with this kind of thinking, had the statues of deities of tribes they had conquered brought to their capital Tenochtitlan and placed inside a prison of dethroned gods within the great temple. They reasoned: how could a conquered people hope to rebel without their gods to lead them?[276]

Due to Yahweh's self-revelation, Israel broke with her polytheistic neighbors and the widely-held view that a god's power was limited to a certain geographical region.[277] The Hebrews joined in an everlasting covenant to a single being who ruled both the heavens and the earth. What other ancient peoples saw as diverse, fragmented phenomena governed by tutelary spirits (e.g., a god for the sun, a god for the sea, a god for the wind), the Israelites subsumed under one self-subsisting, supreme head. This monotheistic legacy, with all its multitudinous ramifications, was bequeathed to her Abrahamic offspring, whether Jew, Christian, or Muslim. To maintain our place in the covenant, we need to ask ourselves every day which idols are usurping the rightful place of God in our lives, then undertake to dethrone them. For I'm afraid history has stood still, as Moses is still coming down from Mt. Horeb, angrily smashing tablets of stone, incensed by the golden calves his stiff-necked people continue to worship (Ex. 32).

> "Behold now, all the gods whom I once used to worship in
> ignorance:

274 "Idol, Idolatry," Leland Ryken, James C. Wilhoit, Tremper Longman III, general editors, *Dictionary of Biblical Imagery* (InterVarsity, 1998), p. 416.

275 *Against the Pagans*, book 1, section 39, Herbert A. Musurillo, translator and editor, *The Fathers of the Primitive Church* (New American Library, 1966), p. 231. Cf. Arnobius of Sicca, *The Case Against the Pagans*, volume 1, translated by George E. McCracken (Newman Press, 1949), pp. 87–88.

276 Chapter 12, Paul Westheim, *The Art of Ancient Mexico*, translated by Ursula Bernard (Anchor, 1965), p. 192.

277 "Monotheism," Walter Brueggemann, *Reverberations of Faith: A Theological Handbook of Old Testament Themes* (Westminster John Knox, 2002), p. 137.

I have now recognized that they were dumb and dead idols,
and I have caused them to be trampled underfoot by men,
and the thieves snatched those that were of silver and gold.
And with you I have taken refuge, O Lord my God."—prayer of
Aseneth[278]

278 "Joseph and Aseneth," 13:11–12, translated by C. Burchard in *The Old Testament Pseude-pigrapha*, volume 2, edited by James H. Charlesworth (Doubleday, 1985), p. 223. Cf. "Prayer of a Convert to Judaism" by Randall D. Chesnutt, *Prayer from Alexander to Constantine: A Critical Anthology*, edited by Mark Kiley, et al. (Routledge, 1997), pp. 65–72.

"A Single Soul Dwelling in Two Bodies"

Ecclesiastes 4:4–12

"Blest Be the Tie That Binds" by John Fawcett

"To the question, 'What is a friend?'" Aristotle replied, "'A single soul dwelling in two bodies.'"—Diogenes Laertius[279]

Life is hardly worth living without friends. Friends are those companions one makes for oneself, regardless of bloodlines. Relationships may begin with similar interests, but soon they blossom into something more, at times even verging on complementary personalities; ties that had been forged during adversity, when one (or both) needed a shoulder to lean on, eventually were strengthened and solidified.

"[T]o make conversation, to share a joke, to perform mutual acts of kindness," are among the activities Augustine enjoyed with companions, "to read together well-written books, to share in trifling and in serious matters, to disagree

279 "Aristotle," Diogenes Laertius, *Lives of the Philosophers*, translated and edited by A. Robert Caponigri (Henry Regnery, 1969), p. 189.

though without animosity—just as a person debates with himself," to learn from or to teach one another.[280] I know I like to go on walks with friends, attend concerts/movies or visit museums, play all manner of games, work side-by-side on community projects, or just have a light lunch together. There are so many ways two individuals can share happiness. There are friends from childhood to reminisce with; colleagues, to further one's professional interests; and friends in old age, where one acts like a crutch for the other. Yes, and despite the cynics, I believe a genuine friendship can exist between a male and a female; think of how Francis inspired Clare to join him, abandon her possessions, found a community of sisters, and become its abbess.

Before a friend, Emerson confided, "I may think aloud."[281] "Oh, the comfort—the inexpressible comfort of feeling safe with a person," sighs the nineteenth-century British novelist Dinah Craik, "having neither to weigh thoughts nor measure words, but pouring them all right out, just as they are, chaff and grain together; certain that a faithful hand will take and sift them, keep what is worth keeping, and then with the breath of kindness blow the rest away."[282] Intimacy of this sort is a rare and precious thing.

"I know of nothing that I could compare with the friendship of Scipio," relates the Roman orator Cicero. "Here I found sympathy for my political opinions, here, advice and assistance in private affairs, here, joy to my hours of ease."[283] Two are better than one, as the reading from Ecclesiastes indicates. Our paths are made more smooth and our lives bear richer fruit when seasoned by sweet times of togetherness with faithful friends. And they are absolutely critical during our hour of need. Lord, could you send us a few more?

"Dear Lord, how the love of my friends towards me rejoices my heart. Who can describe the feeling in the heart that comes from knowing people's love? It is indescribable. To be aware that there are people who love me, even as the miserable sinner that I am, fills me with hope. And the source of the hope is the knowledge that my friends' love for me is a pale shadow of God's love for me."—John Sergieff[284]

280 Book 4, section 13, Augustine, *Confessions*, translated by Henry Chadwick (Oxford University Press, 1992), p 60.

281 "Friendship," Brooks Atkinson, editor, *The Complete Essays and Other Writings of Ralph Waldo Emerson* (Modern Library, 1940), p. 228.

282 Chapter 16, Dinah Maria Craik, *A Life for a Life* (Harper & brothers, 1859), p. 169.

283 "On Friendship," section 27, Cicero, *On Old Age* and *On Friendship*, translated by Frank. O. Copley (University of Michigan Press, 1971), p. 89.

284 Robert Van de Weyer, compiler, *The HarperCollins Book of Prayers* (HarperCollins, 1993), pp. 317–18.

"Sister Water"

Acts 8:26–40
"On Jordan's Bank the Baptist's Cry" (*Jordanis oras praevia*) by Charles Coffin, translated by John Chandler, later amended

"Praised be my Lord for our sister water, who is very serviceable unto us and humble and precious and clean."—Francis of Assisi[285]

"The first principle of things is water," announced the pre-Socratic philosopher Thales, seeing water as the key to all transformation and change.[286] While scientifically this may be dubious, theologically it has merit. By the rite of baptism believers are fully incorporated into the visible church. And "it makes

285 "Prayers of Dependence," Tony Castle, compiler, *The New Book of Christian Prayers* (Crossroad, 1986), p. 132. Cf. "The Canticle of the Creatures," *Francis of Assisi: Early Documents, Volume 1: The Saint*, edited by Regis J. Armstrong, J. A. Wayne Hellman and William J. Short (New City Press, 1999), p. 114.

286 Chapter 1, Milton C. Nahm, *Selections from Early Greek Philosophy* (Prentice-Hall, 1968), pp. 33, 38. Cf. *Metaphysics*, Book 1, section 3, translated by W. D. Ross, *The Complete Works of Aristotle, Volume 2*, edited by Jonathan Barnes (Princeton University Press, 1991), p. 1556.

no difference," declared Tertullian, "whether a man be washed in sea, freshwater stream or spring, lake, or tub."[287]

Baptisteries (reflecting Paul's imagery in Romans 6) could be constructed so as to resemble tombs,[288] for there we die to past sins, then rise up to new life in Christ. An inscription at the Lateran Baptistery exhorts neophytes, "Be submerged, sinners, into the sacred stream for purging: the water will yield up a new man in place of the old one it has received."[289] Water, that universal solvent,[290] signifies forgiveness and the miracle of new beginnings.

Over the centuries, the church has added a number of corollaries to this central rite, e.g., donning white robes, renouncing Satan, having the sign of the cross marked upon one's forehead, being given a Christian name. "[E]very man hath a double Horoscope," noted seventeenth-century essayist Thomas Browne, "one of his humanity, his birth; another of his Christianity, his baptisme, and from this doe I compute or calculate my Nativitie, not . . . esteeming my selfe any thing, before I was my Saviours, and inrolled in the Register of Christ."[291]

Baptism in the early church could be the culmination of weeks of intense instruction—so catechumens were fully aware of the commitment they were making. Yet even such a powerful rite couldn't prevent future lapses. What should one do then? Admit one's error, sincerely repent, throw oneself on the mercy of God, and call to mind one's baptismal vows. "So when I view my sinnes," cried country parson/poet George Herbert, "mine eyes remove/ More backward still, and to that water flie."[292]

"Almighty everlasting God, Father of our Lord Jesus Christ, look upon these your servants whom you have called to the elements of faith. Drive from them all *blindness of heart* . . . : loose the bonds of Satan with which they were bound: open to them, O Lord, the door of your religion: that, bearing the sign of your wisdom, they may turn from the squalor of fleshly lusts and delight in the sweet savor of your commandments and joyfully serve you in your church: that first

287 *On Baptism*, section 4, *The Early Christian Fathers*, edited and translated by Henry Bettenson (Oxford University Press, 1976), p. 147.

288 "Baptistery," Peter and Linda Murray, *The Oxford Companion to Christian Art and Architecture* (Oxford University Press, 1996), p. 45.

289 Quoted in chapter 6, R. A. Markus, *Christianity in the Roman World* (Charles Scribner's Sons, 1974), p. 112. Cf. "Inscriptions in the Roman Churches," A. Hamman, editor, *Early Christian Prayers*, translated by Walter Mitchell (Henry Regnery, 1961), pp. 206–07.

290 Chapter l, Kenneth S. Davis and John Arthur Day, *Water: The Mirror of Science* (Anchor, 1961), pp. 32–33.

291 *Religio Medici*, first part, section 45, *The Prose of Sir Thomas Browne*, edited by Norman J. Endicott (Norton, 1972), p. 52.

292 "H. Baptisme (I)," Dudley Fitts, editor, *Herbert* (Dell, 1966), p. 59.

taking the medicine, they may increase in virtue day by day until by your favor they come to the grace of baptism."—The Gelasian Sacramentary (for the making of a catechumen)[293]

293 Chapter 12, section 30, "Prayers over the Elect," E. C. Whitaker, *Documents of the Baptismal Liturgy*, revised and expanded by Maxwell E. Johnson (Pueblo, 2003), pp. 215–16.

Soul-Wrestling

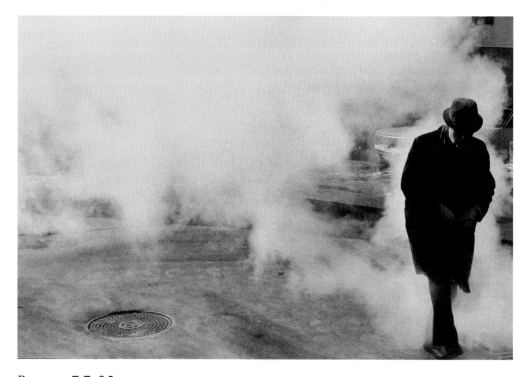

Romans 7:7–25

"Standin' in the Need of Prayer" (African-American spiritual)

"The life of every man is a diary in which he means to write one story, and writes another; and his humblest hour is when he compares the volume as it is with what he vowed to make it."—James Matthew Barrie[294]

The enigmatic, Bible-toting nineteenth-century British general, Charles George Gordon, who took part in expeditions in China and Africa, once confessed to William Beresford that the world was not big enough for him, that there was "no king or country big enough." Then pounding Beresford on the shoulder, he added, "Yes, that is flesh, that is what I hate, and what makes me wish to die."[295]

There is a lifelong struggle inside each of us. Freud interpreted this in terms of

294 Chapter 1, J. M. Barrie, *The Little Minister* (Grosset & Dunlap, 1897), p. 4.

295 "The End of General Gordon," Lytton Strachey, *Eminent Victorians* (Harcourt, Brace & World, no date), p. 269.

the gratifications of the id vs. the restraining power of the superego, Pascal as an ongoing conflict between the designs of the head and of the heart. Plato likened the soul to a charioteer led by two winged horses, one which pulls him up and another which pulls him down.[296] "I am like a man who sees clearly at chess and teaches others very well," notes twelfth-century French poet Conon de Bethune, "but when he plays, then he so loses his head that he cannot escape being checkmated."[297] Each of us, woefully aware of what he ought to do, makes numerous resolutions, but doesn't seem to have the willpower to carry through. There is a perpetual civil war within our members.

As a young man, Italian humanist Francesco Petrarch was given a copy of Augustine's *Confessions* by a monk who became his spiritual father and confessor, Francesco Dionigi de' Roberti. Later, he penned three dialogues between himself and Augustine under the title, *My Secret*, wrestling with the two great "chains" in his life—his love for Laura and his desire for fame. These conflicts appear once again in his seven Latin *Penitential Psalms*.[298] Petrarch is truly ashamed of how much he is pulled by, and attached to, earthly things.[299]

Upon climbing six-thousand-foot Mount Ventoux with his brother Gherardo, he described this self-questioning in a letter to Dionigi, which is dated April 26, 1336: "What I used to love, I love no longer. But I lie: I love it still, but less passionately. Again have I lied: I love it, but more timidly, more sadly. Now at last I have told the truth; for thus it is: I love, but what I should love not to love, what I should wish to hate."[300]

How reminiscent this is of the language of Romans chapter 7, where Paul laments the fact that he is sold into slavery to sin, can't comprehend his own actions, and without Christ's help does what he actually despises. Ironically, by recognizing this impasse and the impotence of his will, he is part way toward the solution, which is known as "living by the Spirit" (Rom. 8:1–17).

"You redeemed me from the slavery of sin. And yet I cannot escape the overpowering sense that I am still a wretched sinner, that my every action is worthless

296 "Phaedrus," sections 253–56, translated by R. Hackforth, *The Collected Dialogues of Plato* edited by Edith Hamilton and Huntington Cairns (Princeton University Press, 1989), pp. 499–502.

297 "Love Song," Brian Woledge, editor and translator, *The Penguin Book of French Verse to the Fifteenth Century* (Penguin, 1966), p. 105.

298 Chapter 8, Ernest Hatch Wilkins, *Life of Petrarch* (University of Chicago Press, 1963), pp. 37–38.

299 "The *Rime sparse*," no. 365, Robert M. Durling, editor and translator, *Petrarch's Lyric Poems* (Harvard University Press, 1979), p. 574.

300 "Petrarch," Amy Mandelker and Elizabeth Powers, editors, *Pilgrim Souls* (Simon & Schuster, 1999), pp. 400, 404.

or evil. . . . Good people try to help me, and I pray that you will reward them; but their goodness does nothing to assuage my sense of wickedness. . . . Lift the burden of wickedness; break down my stubbornness; root out my pride. Let me receive your life-giving love. Let me be free."—Fulbert of Chartres[301]

301 Robert Van de Weyer, compiler, *The HarperCollins Book of Prayers* (HarperCollins, 1993), pp. 158–59.

Speed, Our Master?

Psalm 46

"Be Still, My Soul" (*Stille, mein Wille: dein Jesus hilft siegen*) by Katharina von Schlegel, translated by Jane Laurie Borthwick

"If the engine whistles, let it whistle till it is hoarse for its pains. If the bell rings, why should we run?"—Henry David Thoreau[302]

"It gratifies us," essayist Max Beerbohm asserts, "that Father Newman wrote his lovely *Apologia* in eight weeks, and Samuel Johnson his fine Rasselas in the evenings of one week." We would be equally pleased, contends Beerbohm, if we discovered "that Edward Gibbon wrote the *Decline and Fall of the Roman Empire* in six months, or that Christopher Wren designed St. Paul's Cathedral in twenty-five minutes."[303]

"Speed" and "progress" are two of the watchwords of the modern age. British economist E. F. Schumacher complained of those "people of the forward

302 Chapter 2, Henry David Thoreau, *Walden; or, Life in the Woods* (New American Library, 1960), p. 70.
303 "Speed," Max Beerbohm, *Mainly on the Air* (Heinemann, 1946), p. 19.

stampede" whose motto was "a breakthrough a day keeps the crisis at bay."[304] Their panacea for any technological dilemma was simple—more technology. Thus, nations plunge ahead with nuclear power plants, hoping against hope that some new method will be discovered for disposing of radioactive waste. Witness, too, how swiftly modes of transportation have changed—from horseback/coach to steamship/locomotive to airplane/spaceship—as well as our means of communication—from letter/post to telegraph/telephone to email/texting. Major news events are now simulcast around the globe; weather forecasts are updated continuously to take account of ever-changing conditions; delivery services are thought viable only if they offer overnight or even same-day options.

But what are the casualties of this reckless pace? "A cannon-ball fired from a cannon is not in itself dangerous," Beerbohm wryly comments. "It is dangerous only if you happen to be in the way of it. You would like to step out of its way; but there is no time for you to do so."[305] Consider the hundreds and thousands of fellow human beings (and animals!) who would still be alive if we didn't rush around so in our automobiles. And how much less pollution and smog would be choking our cities, if we didn't nonchalantly deplete the world's fossil fuels. And how many fewer nervous breakdowns would occur, if we weren't so anxious to move from point A to point B as though acceleration were the be-all and end-all?

Time, for the believer, doesn't mean setting some new land speed record or being the first in your neighborhood to adopt the latest technological innovation; it means being open to the opportunities God lays before us. Thus Jewish mystic Abraham Heschel spoke of an architecture of "holiness" whereby we construct "a palace in time" (rather than space), for "[e]very hour is unique . . . and endlessly precious."[306] Then by "each decision we take, each action we begin, each sacrifice we make," declares Belgian literary critic Georges Poulet, "it is possible for us to give time a new and permanent inflection."[307] Though running helter-skelter may give one the illusion of doing something of consequence, it may simply mask our inability to sit still. A blind John Milton concluded, "They also serve who only stand and wait."[308]

"O Lord, calm the waves of this heart; calm its tempests! Calm thyself, O my soul, so that the divine can act in thee!"—Søren Kierkegaard.[309]

304 Chapter 5, E. F. Schumacher, *Small Is Beautiful* (Harper & Row, 1975), pp. 155–56.

305 Beerbohm, *Mainly on the Air*, p. 22.

306 "Prologue" and "Part One," Abraham Joshua Heschel, *The Sabbath: Its Meaning for Modern Man* (Farrar, Straus and Giroux, 1994), pp. 8–9, 16.

307 "Appendix: T. S. Eliot," Georges Poulet, *Studies in Human Time*, translated by Elliott Coleman (Harper & Brothers, 1959), p. 358.

308 "Sonnet 19," John T. Shawcross, editor, *The Complete Poetry of John Milton*, revised (Anchor, 1971), p. 243.

309 Perry D. LeFevre, editor, *The Prayers of Kierkegaard* (University of Chicago Press, 1963), p. 43.

Spiritual Rumination

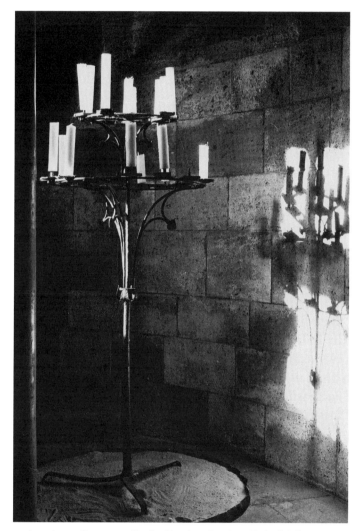

Psalm 119:97–105, 129–36

"Blessed Jesus, at Thy Word" (*Liebster Jesu, Wir Sind Hier*) by Tobias Clausnitzer, translated by Catherine Winkworth

"Some part of your daily reading should, each day, be stored in the stomach, that is in the memory, so that it may be digested. At times it should be brought up again for frequent rumination."—William of St. Thierry[310]

Each of us should set aside a short time each day for spiritual reading and prayer to draw us back to God as the focus for our lives. This has variously been called meditation, ruminating on the Word, quiet time. Roman Catholic theologian Friedrich von Hügel compared it to "letting a very slowly dissolving lozenge melt imperceptibly in your mouth," adding that such reading is meant to move us away "from the book, to the realities it

310 Quoted in chapter 8, Michael Casey, *Toward God* (Triumph, 1996), p. 78. Cf. Chapter 31, William of St. Thierry, *The Golden Epistle*, translated by Theodore Berkeley (Cistercian Publications, 1971), p. 52.

suggests."[311] We should ask God, Cistercian monk Michael Casey recommends, "What do you want of me? How can I hear what you are saying and allow it to shape my life?" Or we may form a prayer or collect of the passages we've just read.[312] Soon a whole chain of associations comes flooding in which can revamp our entire perspective. Making a diary or journal, too, as the founder of Methodism, John Wesley, discovered during his decades of fruitful ministry, can be a spur to good works and examination of conscience.[313]

Lectio divina as it has been practiced by monks for centuries consists of reciting verses from Scripture, so as to "read, mark, learn, and inwardly digest" them, as *The Book of Common Prayer* (1549) puts it.[314] Unlike the rapid, silent reading we do today, the ancients pronounced each individual syllable; this allowed the text to make a greater overall impression since more senses were involved. The monks were not so much interested in gleaning new information as in praying with (and even memorizing) the text. Pondering its meaning and implications during the day was a means of spiritual formation—they were assimilating its nutritive value within the fibers of their being.[315]

To give you some idea of the effect of *lectio divina*, listen closely to an audio-tape or CD of a book which you recently read. Were you startled by passages you had overlooked? Did you form an altogether different impression of certain favorite chapters? *Lectio divina* causes one to slow down and penetrate more deeply. By ruminating on the oracles of God, our minds become like India rubber that can be pulled and stretched in all manner of unforeseen directions.

"O Gracious God and most mercifull Father, which hast vouchsafed us the rich and precious jewell of thy holy word, assist us with thy spirit, that it may be written in our hearts to our everlasting comfort, to reform us, to renew us according to thine owne Image, to build us up, and edifie us into the perfect building of thy Christ, sanctifying and encreasing in us all heavenly vertues. Graunt this, O heavenly Father, for Jesus Christes sake. Amen"—Geneva Bible[316]

311 "To a Friend in his last illness (March 6, 1916)," Friedrich von Hügel, *Selected Letters: 1896–1924*, edited by Bernard Holland (Dutton, 1933), p. 229.

312 Casey, *Toward God*, pp. 78–79.

313 Chapter 7, Richard P. Heitzenrater, *The Elusive Mr. Wesley*, second edition (Abingdon, 2003), pp. 112–14.

314 "The Second Sunday in Advent," *The Collects of Thomas Cranmer*, compiled by Frederick Barbee and Paul F. M. Zahl (Eerdmans, 2006), p. 4.

315 Chapters 1 and 5, Jean Leclercq, *The Love of Learning and the Desire for God*, translated by Catharine Misrahi (Fordham University Press, 1977), pp. 16–22, 89–93.

316 *The Geneva Bible*, a facsimile of the 1599 edition, introduced by Michael H. Brown (Geneva Publishing Co., 1990), following the title page. Found in most printings after 1578.

Sports-Obsession

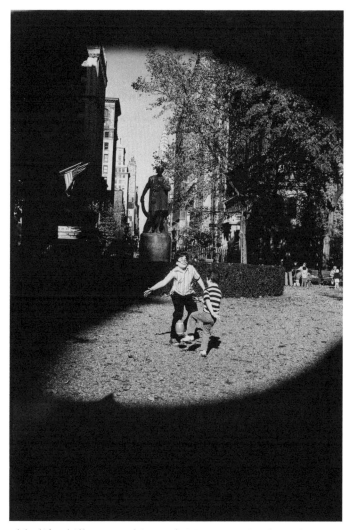

Ecclesiastes 2:1–11; 1 Timothy 4:6–10 "Jesus Calls Us: O'er the Tumult" by Cecil Frances Alexander

"Men spend their time chasing a ball or a hare; it is the very sport of kings."—Blaise Pascal[317]

Ever since Thomas Arnold, headmaster of Rugby from 1828 to 1842, first organized games in the English public school, sports have taken on a major role in modern education and culture at large. No doubt such activities as track, tennis, or basketball offer fine forms of exercise, stimulate the mind, encourage socialization, as well as honor team discipline and individual achievement; hence commendable life skills are cultivated. However, in America, sports have too often come to overshadow the classroom, grown overly-competitive, and instead of involving as many young people as possible, have focused more on star performers.[318] Finally,

317 Fragment # 141, Blaise Pascal, *Pensees*, revised, translated by A. J. Krailsheimer (Penguin, 1995), p. 8.
318 Chapter 5, A. D. C. Peterson, *A Hundred Years of Education*, second edition, revised (Collier, 1962), pp. 108–13.

the inordinate attention the media gives to professional sports and the staggering salaries today's athletes (and entertainers in general!) command far outweigh their real contribution to society.

Such a dilemma is not new. "My sermons are applauded merely from custom," moaned early church orator John Chrysostom in A.D. 399, "then everyone runs off to [horse racing] again and gives much more applause to the jockeys, showing indeed unrestrained passion for them! There they put their heads together with great attention, and say with mutual rivalry, 'This horse did not run well, this one stumbled,' and one holds to this jockey and another to that. No one thinks any more of my sermons, nor of the holy and awesome mysteries that are accomplished here."[319] The *plebs*, or common people, the Roman satirist Juvenal insisted, clamor for *panem et circenses*, bread and games.[320] Spectators at the Circus Maximus reveled in horse and chariot racing; in the amphitheater they might indulge their unbridled lusts in wild animal shows or the gruesome gladiator contests.[321]

This preoccupation with pleasures and what's trivial, according to Pascal, betrays a tendency to avoid such ultimate questions as God and death. We drift along "without reflection," seeking to "annihilate eternity" by "attaining instant happiness."[322] Such diversions, however meant to keep boredom and anxiety at bay, may actually anesthetize us by frittering away worthwhile passions and energy on vacuous forms of entertainment.[323] While there's nothing wrong with most forms of relaxation and amusement, proportion does matter; such activities shouldn't swallow up excessive amounts of our time. Some of the greatest struggles in the spiritual life are not between good and obvious evil, but between the mediocre and what's even better. Like some magnetic compass, our needle should always be pointing toward true north, or the kingdom of heaven (Matt. 6:33).

"Take from me Lord, all slothfulness, and give me a diligent and an active spirit, and wisdom to choose my employment: that I may do works proportionable to my person and to the dignity of a Christian, and may fill up all the

319 Quoted in "John Chrysostom," Editors of "Christian History" Magazine, *131 Christians Everyone Should Know* (Broadman & Holman, 2000), p. 84. Cf. Chapter 10, J. N. D. Kelly, *Golden Mouth: The Story of John Chrysostom* (Cornell University Press, 1995), p. 131.

320 Decimus Iunius Iuvenalis, *The Satires*, X:78 in *The Anchor Book of Latin Quotations*, compiled by Norbert Guterman (Anchor, 1990), pp. 324–25.

321 Chapter 6, "Shows and Spectacles," F. R. Cowell, *Life in Ancient Rome* (Capricorn, 1975), pp. 171–79. Chapter 8, Jerome Carcopino, *Daily Life in Ancient Rome*, second edition (Yale University Press, 2003) annotated and translated by E. O. Lorimer, edited by Henry T. Rowell, pp. 202–21, 231–44.

322 Fragment # 195, Pascal, *Pensees*, pp. 133–34.

323 "Introduction," Krailsheimer, *ibid.*, p. xxiv.

spaces of my time with actions of religion and charity; . . . that my dearest Lord at his sudden coming may find me busy in lawful, necessary, and pious actions; improving my talent intrusted to me by Thee, my Lord."—Jeremy Taylor.[324]

324 *The Rule and Exercises of Holy Living*, chapter 1, "Prayers and Devotions," Jeremy Taylor, *The Rule and Exercises of Holy Living/The Rule and Exercises of Holy Dying* (Longmans, Green & Co., 1941), p. 31.

Stupor et Admiratio

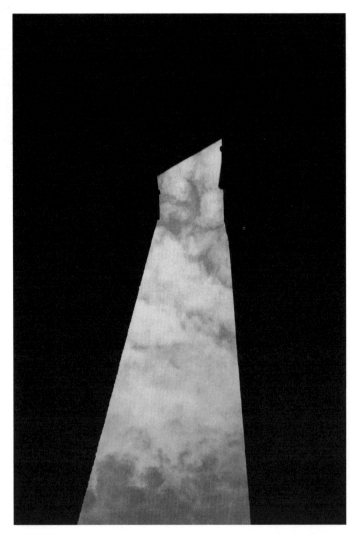

1 Corinthians 11:23–32 "Let All Mortal Flesh Keep Silence" (*Sigesato Pasa Sarx Broteia*) from the Liturgy of St. James, translated by Gerard Moultrie or "I Come with Joy to Meet My Lord" by Brian A. Wren

"The thought of Christ, his words, his works and his sacraments may produce two reactions in man: either we understand the truth, or by the infusion of a higher grace, we experience something sweet: in either case, we are admiring and astounded, *admirantes et stupentes*." —Jean Leclercq[325]

Leclercq is here quoting a phrase from Baldwin of Ford, who calls his attitude during Eucharist *stupor et admiratio*, numbness and surprise.[326] Approaching that common table and partaking of the one loaf and the one cup, we call to mind Christ's broken body and his blood poured out on our behalf—a sacrificial death now mysteriously linked with

325 Chapter 9, Jean Leclercq, *The Love of Learning and the Desire for God*, translated by Catharine Misrahi (Fordham University Press, 1977), pp. 282–83.

326 Jean Leclercq, "Introduction," Baudouin de Ford, *Le Sacrement de L'autel*, volume 1 (Les Editions du Cerf, 1963), p. 47.

his living presence. We are transported back to that last supper when his disciples dined together with their teacher, while Judas, the betrayer, exited to set the sacrifice in motion. In Gregory Dix's seminal study *The Shape of the Liturgy*, he discerned four actions central to the Eucharist: taking the bread and wine and putting them on the table; giving thanks; breaking the bread; then distributing the elements.[327]

"After this ye hear the chanter, with a sacred melody inviting you to the communion of the holy mysteries, and saying, 'O taste and see that the Lord is good,'" Cyril of Jerusalem wrote concerning the rites in the fourth-century church. "Trust not the decision to thy bodily palate; no, but to faith unfaltering; for when we taste we are bidden to taste, not bread and wine, but the sign of the body and blood of Christ.

"Approaching, therefore, come not with thy wrists extended, or thy fingers open; but make thy left hand as if a throne for thy right, which is on the eve of receiving the king. And having hollowed thy palm, receive the body of Christ, saying after it, Amen."[328] By stretching out our hands, we identify with the one who died for us. In accepting his voluntary sacrifice, we are vouchsafed into God's keeping.

To participate worthily we must first examine ourselves (1 Cor. 11:28) and be reconciled to our brothers and sisters (Matt. 5:23–24). "Wouldest thou eat the Body of the Master?" asks the Eastern Orthodox liturgy. "Take heed as thou drawest near lest it burn thee. It is fire. Wouldest thou drink the Divine Blood unto communion? First make thy peace with them that grieve thee; then be of good courage, and eat the sacred food."[329] This solemn, but joyous rite, spurring inward renewal, re-enacts how God's brokenness (and our own) are gradually working to transfigure the cosmos.

"The offered Christ is distributed among us. Alleluia! He gives his body as food, and his blood he pours out for us. Alleluia! Draw near to the Lord and be filled with his light. Alleluia! Taste and see how sweet is the Lord. Alleluia!"—Armenian liturgy.[330]

327 Chapter 4, Dom Gregory Dix, *The Shape of the Liturgy* (Dacre, 1978), p. 48.

328 Chapter 8, James F. White, *Documents of Christian Worship* (Westminster/John Knox, 1992), p. 191. Cf. "Mystagogical Lectures," 5:20, Leo P. McCauley and Anthony A. Stephenson, translators, *The Works of Saint Cyril of Jerusalem*, volume 2 (Catholic University of America Press, 1970), pp. 202–03.

329 "The Communion," Evelyn Underhill, compiler, *Eucharistic Prayers from the Ancient Liturgies* (Longmans, Green and Co., 1952), p. 86. Cf. "The Office of Preparation for Holy Communion," Fellowship of SS. Alban and Sergius, *The Orthodox Liturgy* (SPCK, 1975), p. 7.

330 Ibid., p. 87. Cf. Chapter 4, "The Liturgy of the Armenians," F. E. Brightman, editor, *Liturgies Eastern and Western*, volume 1 (Oxford: The Clarendon Press, 1965), pp. 449–50.

Symbolic Acts

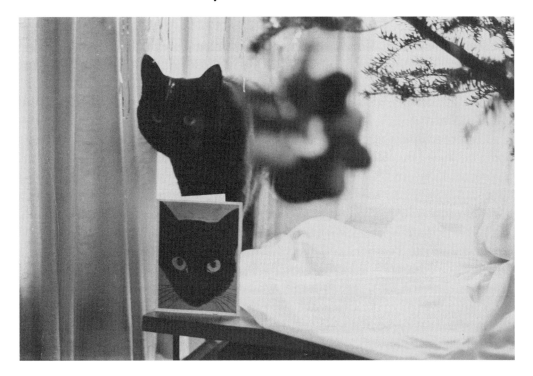

Ephesians 4:17–5:2

"Lord, I Want to Be a Christian" (African-American spiritual)

"Make Christ the only goal of your life. Dedicate to him all your enthusiasm, all your effort, your leisure as well as your business. And don't look upon Christ as a mere word, an empty expression, but rather as charity, simplicity, patience, and purity."—Desiderius Erasmus[331]

Jesus is the primary role model for all Christian behavior. By immersing ourselves in the Gospels, we learn more about what he said, did, and thought. Broadminded souls like nineteenth-century Transcendentalist Ralph Waldo Emerson took sharp exception to this "noxious exaggeration about the *person* of Jesus," preferring instead, to borrow from traditions outside Christianity and to follow the infinite law within: "The soul knows no persons. It invites every man to expand

331 Section II, fourth rule, *The Handbook of the Militant Christian*, John P. Dolan, translator, *The Essential Erasmus* (New American Library, 1964), p. 58.

to the full circle of the universe, and will have no preferences but those of spontaneous love."[332]

Jesus, though, is the life-changer par excellence. "I will show you him that was a lion till then, and is now a lamb;" shouted John Wesley, "him that was a drunkard, and is now exemplarily sober; the whoremonger that was, who now abhors the very 'garment spotted by the flesh.'"[333] In Christ new impulses start to bubble up; old sinful habits subside. Thus, in his letter to the Ephesians, Paul urged former thieves to make an honest living and to share what they earn with those in need (Eph. 4:28). What a turnaround!

In every age and every conceivable manner, Jesus turns lives upside down. Commenting on painter/engraver Albrecht Dürer's acceptance of the teachings of Martin Luther, art historian Erwin Panofsky writes that there was a "conversion—both in subject manner and in style." This man "who had done more than any other to familiarize the Northern world with the true spirit of pagan Antiquity now practically abandoned secular subject matter except for scientific illustrations, traveler's records and portraiture." Instead, Dürer chose to concentrate on religious images as of the evangelists, apostles, and Christ's own passion—moving from a decorative style to a more three-dimensional, "cubistic" one.[334]

In the Four Gospels Jesus's life is vividly etched in by a series of such symbolic acts as turning water into wine; healing the sick and lepers; casting out demons; calling the twelve; sending out the seventy; feeding the five thousand; teaching in parables; cleansing the temple; raising Lazarus from the dead; entering Jerusalem in triumph during Passover; washing the feet of the disciples; holding a last meal; willingly suffering an ignominious death. By conveying God's message in acts supercharged with meaning, Jesus followed in a long line of prophets who conveyed God's message. Jeremiah wore a yoke around his neck (Jer. 27:1–11); Isaiah walked about "naked" and barefoot (Isa. 20:1–5); Ezekiel sketched a diagram of Jerusalem onto a brick and constructed a miniature siege works (Ezek. 4:1–3); Moses performed a series of signs and wonders before Pharaoh (Exod. 7–12); Hosea married a whore (Hos. 1:1–8).

It is clear that we must heed not only prophetic words, but deeds. Church history is also filled to overflowing with countless instances of saints who have

332 "An Address," Mark Van Doren, editor, *The Portable Emerson* (Viking, 1965), pp. 54–55. Cf. Chapter 16, Jaroslav Pelikan, *Jesus Through the Centuries* (Yale University Press, 1985), pp. 202–03.

333 "Sunday, May 20, 1739," Nehemiah Curnock, editor, *The Journal of the Rev. John Wesley, A.M.*, volume 2 (Epworth Press, 1938), p. 202.

334 Chapter 7, Erwin Panofsky, *The Life and Art of Albrecht Dürer*, fourth edition (Princeton University Press, 1955), pp. 199–200. Cf. Chapter 13, Pelikan, *Jesus Through the Centuries*, pp. 161–62.

confronted the world through all manner of faith-filled antics which challenged the prevailing order. Such acts can serve as templates for what we mortals may hope to accomplish in Jesus's name.

Let us attend to both Jesus's words *and* deeds with reverence and awe. Help us more fully fathom the significance of all he said and did, letting it take root in our everyday lives. May his speech *and* actions be an artesian well for our confused and wandering souls, infusing all we say or do with their truth and meaning.

"That They May All Be One"

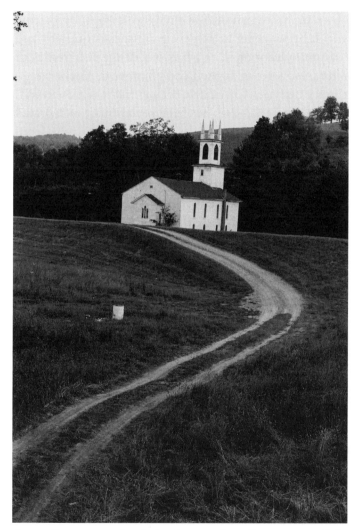

John 17:15–26
"Christ Is Made the Sure Foundation" (*Angularis fundamentum*) by anonymous, translated by John Mason Neale or "The Church's One Foundation" by Samuel John Stone

"[I]t's one for all and all for one. That's our motto."—D'Artagnan in *The Three Musketeers*[335]

Christ's church has splintered into a seemingly endless number of denominations and sects. There are differences concerning doctrine, types of church government, the language used in worship, which sacraments are recognized, the kinds of music allowed, the title and role of the presiding officer. . . . In some cases these divergences hark back to unbending personalities who had trouble relating to an overarching authority structure; on other occasions they are due to dubious or idiosyncratic readings of Scripture; not a few stem from customs which were considered "worldly" at a certain point in history, so that a line was drawn in the

335 Chapter 7, Alexandre Dumas, *The Three Musketeers*, no translator (Lightyear Press, 1976) p. 74.

sand; quite a few relate to factors of ethnicity, race, class, or national boundaries.[336] However, concerning the church as the bride of Christ, Augustine proclaimed in one of his sermons, "Let there be plenty of variety in the garment, but no tear."[337]

The modern ecumenical movement, which began appropriately enough on the mission field, has valiantly sought to re-establish a unity between these scattered pieces of the puzzle. Oneness has been pursued from a series of angles, explains theologian Jaroslav Pelikan, by establishing an institutional framework, by sharing in Christian service to the world, by working to achieve a consensus on faith and doctrine,[338] by producing a common lectionary. . . . It is one of the sad ironies of church history that communion (also known as the Lord's Supper or Eucharist), a practice which should foster unity between Christians, seeing that it is a memorial of Jesus's death until he returns (1 Cor. 11:23–26), has been so variously interpreted as to how the bread should be broken; what kind of "wine" should be drunk from the cup; who should and should not be invited to partake; the exact nature of Christ's presence—that barriers have been raised, instead of doors flung open.

The 17th chapter of John's Gospel, however, makes it clear that Christ yearns for believers to transcend these manmade divisions in order to witness to that unity at the very heart of God's being. Church fathers like John of Damascus used the Greek term *perichoresis* (meaning "interpenetration" or "co-inherence") as a way of describing both the relationship between Jesus's divine and human nature as well as conveying the mutual attraction and intimacy between Father, Son, and Holy Spirit.[339] In *The Trinity* Augustine grapples mightily to understand the nature of this inner dynamic. One of the most influential images he comes up with is that of the lover, the beloved, and love itself.[340] If Christians interacted with each other in the manner of the members of the Trinity, unity would be fundamental, a cornerstone.

"Gracious Father, I humbly beseech thee for thy holy catholic church, fill it with all truth, in all truth with all peace. Where it is corrupt, purge it; where it is in error, direct it; where it is superstitious, rectify it; where anything is amiss, re-form it; where it is right, strengthen and confirm it; where it is in want, furnish it; where it is divided and rent asunder, make up the breaches of it; O thou holy one of Israel."—William Laud[341]

336 H. Richard Niebuhr, *The Social Sources of Denominationalism* (Meridian, 1964).

337 Psalm 44 [45], section 24 (on verse 10), Augustine, *Expositions of the Psalms 33–50*, translated by Maria Boulding, edited by John E. Rotelle (New City Press, 2000), p. 302.

338 "Church," Jaroslav Pelikan, *The Melody of Theology* (Harvard University Press, 1988), p. 39.

339 *"Perichoresis,"* Ken Parry, David J. Melling, Dimitri Brady, Sidney H. Griffith and John F. Healey, editors, *The Blackwell Dictionary of Eastern Christianity* (Blackwell, 2001), p. 376.

340 Book 8, section, 14, Augustine, *The Trinity*, translated by Edmund Hill, edited by John E. Rotelle (New City Press, 1991), p. 255.

341 "A Summarie of Devotions: *Ecclesia*," William Laud, *The Works*, volume 3, edited by James Bliss (J. H. Parker, 1853), p. 67.

Transparent as Glass

1 Corinthians 2:9–16

"Come Down, O Love Divine" (*Discendi, Amor santo*) by Bianco of Siena, translated by Richard F. Littledale or "Lord Jesus, Think on Me" (*Mnoheo Christe*) by Synesius of Cyrene, translated by Allen William Chatfield

"[I]n the beginning was the mask."—Antonio Machado[342]

Who am I really? I mean deep down in my heart of hearts. What moves me to get up each morning to run the series of hurdles of yet another indeterminate day? What sustains and encourages me, pulling me ever onwards? Which are my short- and long-term goals or the rewards I am seeking? Am I anxious for respect? status in my community? a comfortable material existence? Do I hunger for a splashy discovery which will put my name in lights or simply desire that my children have a better future? What kind of legacy do I want to bequeath?

Adam and Eve, following the Fall, stitched together loin cloths of fig leaves to

342 "Poem 41: Proverbs and Song-verse," section 47, Antonio Machado, *Selected Poems*, translated by Alan S. Trueblood (Harvard University Press, 1982), p. 189.

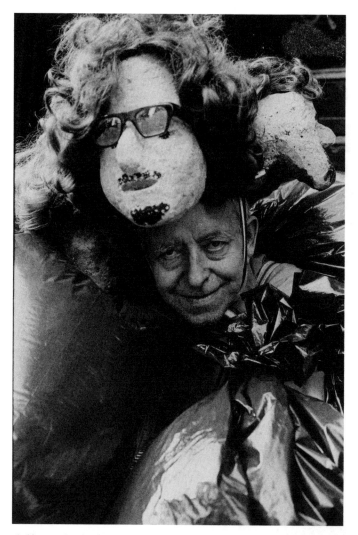

cover their nakedness and tried to "hide" from God (Gen. 3:6-8). No human being is ever wholly transparent, either to himself or to others. Our normal attire is camouflage fatigues; our inmost thoughts and feelings, a confusing riddle. Over a lifetime we've accumulated an entire wardrobe of subterfuges which permit only fleeting exposure. "I never utter my real feelings about anything," the teenage Anne Frank blurted out to her diary, "and that's how I've acquired the name of chaser-after-boys, flirt, know-all, reader of love stories. The cheerful Anne laughs about it, gives cheeky answers, shrugs her shoulders indifferently, behaves as if she doesn't care, but, oh dearie me, the quiet Anne's reactions are just the opposite."[343]

Being "visible," as any animal knows, leaves one open to attack.[344] "We conceal and camouflage our true being," psychologist Sidney Jourard supposes, "to foster a sense of safety, to protect ourselves against unwanted but expected criticism, hurt, or rejection."[345] Yet if we are to truly play the role God intended, we must be willing to be as vulnerable as the Christ, who was himself born in a manger subject to the vicissitudes of existence, prey to the slings and insults of human

343 "Tuesday, 1 August, 1944," Anne Frank, *The Diary of a Young Girl*, translated by B. M. Mooyaart (Washington Square, 1972), pp. 240–41.

344 Chapter 7, R. D. Laing, *The Divided Self* (Penguin, 1970), p. 110.

345 "Preface," Sidney M. Jourard, *The Transparent Self* (Van Nostrand Reinhold, 1964), p. iii.

cruelty. Then do we admit to ongoing flaws, pass on significant lessons of the heart, strive for the good as we understand it. . . .

Cappadocian father Basil of Caesarea compared the Christian to a glass which first had been cleansed from impurities, then became radiant due to the divine light within:[346] "When a sunbeam falls on a transparent substance, the substance itself becomes brilliant, and radiates light from itself. So too Spirit-bearing souls, illumined by him, finally become spiritual themselves, and their grace is sent forth to others."[347] Thus will transparent souls radiate Christ's light to all they meet. God wants people, as Francois Fenelon avows, who are not "forever striking poses in the mirror."[348]

"Almighty God, unto whom all hearts be open, all desires known, and from whom no secrets are hid: Cleanse the thoughts of our hearts by the inspiration of thy Holy Spirit, that we may perfectly love thee, and worthily magnify thy holy Name; through Christ our Lord."—*The Book of Common Prayer* (1662), translated from the Sarum Missal.[349] Sovereign Lord, incinerate our masks, purge our conceits, remove those facades we have assumed for appearances' sake. Permeate our hearts with your celestial glimmers.

346 John McGuckin, "The Eastern Christian Tradition," Chapter 4, *The Story of Christian Spirituality*, edited by Gordon Mursell (Fortress, 2001), p. 131.

347 Chapter 9, St. Basil the Great, *On the Holy Spirit*, translated by David Anderson (SVS Press, 1980), p. 44.

348 Quoted in chapter 12, Andre Comte-Sponville, *A Small Treatise on the Great Virtues*, translated by Catherine Temerson (Metropolitan Books, 2001), p. 153. Cf. Letter 132, "Simplicity and Self-Consciousness," Francois de Salignac de la Mothe Fenelon, *Spiritual Letters of Archbishop Fenelon: Letters to Women*, no translator (Dutton, 1878), p. 263.

349 "Collects from the Order of the Holy Communion," Vivien Morris, compiler, *A Prayer for All Seasons: The Collects of the Book of Common Prayer* (Lutterworth, 1999), p. 69.

"The Tree with the Lights in It"

Luke 9:28–35

"Come, Thou Holy Spirit Bright" (*Veni, sancte Spiritus*) attributed to Stephen Langston, translated by Charles P. Price

"He fumbles at your Soul
As Players at the Keys,
Before they drop full Music on—
He stuns you by degrees."—Emily Dickinson[350]

All of the known universe is subject to the second law of thermodynamics—that in every closed system entropy (or disorder) tends to increase. There is a directionality in nature. You can break open eggs to make an omelet, but you can't reverse the process. You can uncork a bottle of perfume, but you can't put the scent back inside.[351] Jesus's transfiguration, however, hints at, and his resurrection makes explicit, that a different law is at work in the spiritual realm.

350 No. 315, *The Complete Poems of Emily Dickinson*, edited by Thomas H. Johnson (Little, Brown and Company, 1960), p. 148.

351 "Thermodynamics, Second Law of," James Trefil, *The Nature of Science* (Houghton Mifflin, 2003), pp. 399–401.

"Seeing the glory of the Lord" (2 Cor. 3:18 NRSV), "his clothes became dazzling white" (Luke 9:29 NRSV), and "the skin of his [Moses'] face shone" (Ex. 34:29 NRSV)—all denote a strong visual element in transfiguration. "Many things catch the light prismatically," notes Diane Ackerman in *A Natural History of the Senses*, "fish scales, the mother-of-pearl inside a limpet shell, oil on a slippery road, a dragonfly's wings, opals, soap bubbles, peacock feathers . . . metal that's lightly tarnished . . . but perhaps best known is water vapor. When it's raining but the sun is shining, or at a misty waterfall, sunlight hits the prismlike drops of water and is split into what we call a 'rainbow.'"[352] Such iridescence momentarily stuns us.

In Annie Dillard's Pulitzer-prize winning *Pilgrim at Tinker Creek* there is a chapter called "seeing." Here she tells the story of a blind girl who has recently been healed. When the doctor takes off the bandages and leads the girl into the garden, the girl reports seeing "the tree with the lights in it." This tree, for Dillard, became a kind of metaphor which haunted her existence until one day she, too, "saw the backyard cedar where the mourning doves roost charged and transfigured, each cell buzzing with flame."

"I had been my whole life a bell," she suddenly realized, "and never knew it until at that moment I was lifted and struck." And she's been ringing ever since. "I have since only very rarely seen the tree with the lights in it. The vision comes and goes, mostly goes, but I live for it, for the moment when the mountains open and a new light roars in spate through the crack, and the mountains slam."[353] For the Christian, this is that moment when material reality reveals its spiritual imprint, when the human Jesus is manifest as God's own beloved son, when our stale, mundane lives are transformed into something worthy of eternity. We yearn for God's presence, knowing that such moments of epiphany are few and far between. But when they do occur, we want to turn handsprings and shout "Encore!"

"I was sitting in the light of a lamp that was shining down on me, lighting up the darkness and shadows of the night, where I was sitting to all appearances busy in reading, but more engaged in meditating on the ideas and concepts. While I was meditating on such things, master, suddenly you yourself appeared from on high, far greater than the sun itself, shining brilliantly from the heavens down into my heart. . . . What intoxication of the Light! What swirlings of fire! What dancing of the flame of you and your glory within me."—Symeon the New Theologian[354]

352 "Vision: How to Watch the Sky," Diane Ackerman, *The Natural History of the Senses* (Random House, 1990), pp. 244–45.

353 Chapter 2, Annie Dillard, *Pilgrim at Tinker Creek* (HarperPerennial, 1988), pp. 33–34.

354 *Hymns of Divine Love* 25, quoted in chapter 7, John Anthony McGuckin, *Standing in God's Holy Fire: The Byzantine Tradition* (Orbis, 2001), pp. 113–14.

Under God's All-Seeing Eye

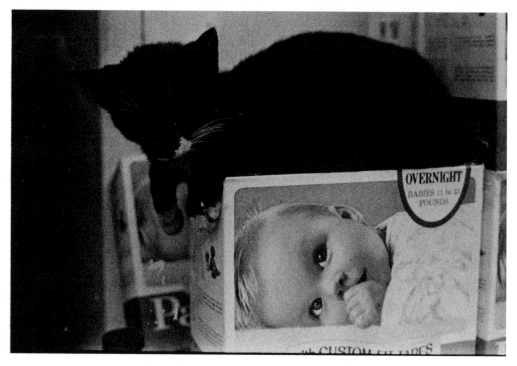

Psalm 104:24–33; Matthew 6:25–34

"Praise to the Lord! the Almighty, the King of Creation" (*Lobe den Herren*) by Joachim Neander, translated by Catherine Winkworth or "The Lord's My Shepherd" in the Scottish Psalter (1650)

> "A speckled cat and a tame hare
> Eat at my hearthstone
> and sleep there;
> And both look up to me alone
> For learning and defence
> As I look up to Providence."—W. B. Yeats[355]

Providence, rightly understood, means blessings poured out on us are not dependent on individual virtue and piety, nor are misfortunes which befall us

355 "Two Songs of a Fool," W. B. Yeats, *The Collected Poems of W. B. Yeats* (Macmillan, 1979), p. 166.

necessarily due to personal faults and mistakes. There is no simple cause-and-effect law of karma at work in the known universe; otherwise, what would be the point of a future judgment? Instead, we find an overarching benevolence riddled with instances of both deserved and undeserved suffering—and God's care manifest in an uninterrupted series of daily ministrations.

"Most of us have been loved beyond our deserving, forgiven when we dared not believe it possible, sustained by the patience of others when they have had grounds to reject us," relates ethicist James Gustafson. "We have received from the sustaining powers of the sun and the earth, the social order and the culture, more than we could ever claim to deserve. These experiences point to the goodness of God."[356] Following in the footsteps of the prophet Samuel, we should all be constructing Ebenezers (stones of help), since "[t]hus far the Lord has helped us" (1 Sam. 7:12 NRSV). "Let us humbly and reverently attempt to trace his guiding hand," commends nineteenth-century Tractarian John Henry Newman. "Let us thankfully commemorate the many mercies he has vouchsafed to us in time past, the many sins he has not remembered, the many dangers he has averted, the many prayers he has answered, the many mistakes he has corrected, the many warnings, the many lessons, the much light, the abounding comfort which he has from time to time given."[357]

Irenaeus, the first major theologian in the early church, used the image of God holding the world (and all of creation) in the palm of his hand as a way of depicting God's sustaining power and nearness.[358] Think of that African-American spiritual, "He's Got the Whole World in His Hands." In the fifteenth century Nicholas of Cusa compared the immediacy and presence of God to an illusion—in which the eyes of a stationary picture appear to see simultaneously in every direction.[359] Comments Nicholas, one "observes how this gaze deserts no one," yet, at the same time, "takes diligent care of each, just as if it cared only for the one on whom its gaze seems to rest and for no other."[360]

God is the most caring being in the universe; his primary attribute is love (1 John 4:7–8), so why do little things still upset us? Today is the tomorrow we worried ourselves sick about yesterday. That mountain we had to climb this morn-

356 Chapter 8, James M. Gustafson, *Theology and Christian Ethics* (Pilgrim Press, 1974), p. 170.

357 "Remembrance of Past Mercies," John Henry Newman, *Parochial and Plain Sermons* (Ignatius, 1997), p. 1012.

358 Chapter 1, Jonathan Hill, *The History of Christian Thought* (InterVarsity, 2003), pp. 27–28. Cf. *Against Heresies*, book 4, chapter 19, section 2, W. A. Jurgens, translator, *The Faith of the Early Fathers*, Volume 1 (Liturgical, 1970), p. 96.

359 James E. Biechler, "Nicholas of Cusa," *The Westminster Dictionary of Christian Spirituality*, edited by Gordon S. Wakefield (Westminster, 1983), p. 279.

360 "Preface," *On the Vision of God*, H. Lawrence Bond, translator, *Nicholas of Cusa: Selected Spiritual Writings* (Paulist, 1997), p. 236.

ing, by mid-afternoon looks more like a molehill; that searing tragedy, yet another test for our stamina. The future rests entirely in God's hands (Rom. 8:28); let us then, as Jesus trumpets, live as spontaneous and carefree as the lilies of the field or the birds in the air (Matt. 6:26–30).

> "Lead, kindly light, amid the encircling gloom,
>> Lead thou me on;
> The night is dark, and I am far from home;
>> Lead thou me on.
> Keep thou my feet; I do not ask to see
>> The distant scene: one step enough for me."—John Henry Newman[361]

361 "(Guidance)," Donald Davie, editor, *The New Oxford Book of Christian Verse* (Oxford University Press, 1983), p. 225.

The Virtue of Humor

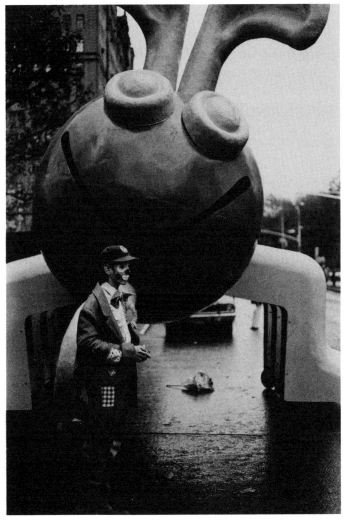

Psalm 126
"Lord of the Dance" by Sydney Carter

"All of us ought to be ready to laugh at ourselves because all of us are a little funny in our foibles, conceits, and pretensions."—Reinhold Niebuhr[362]

If whodunit mysteries presume that all of us are capable of heinous sin, possibly even murder given the right circumstances, then comedy takes it for granted that there is some enormous discontinuity, a crack in the known universe, which points to our need for redemption.[363]

One of my favorite books is Cervantes' *Don Quixote*. The main character gave rise to a new adjective: "quixotic," meaning one who is a visionary idealist eager to set the world right through the sheer force of his personality. More often than not though, the protagonist's actions prove ineffectual, even pathetic. Picture a lanky knight in rusty

362 "Humour and Faith," Robert McAfee Brown, editor, *The Essential Reinhold Niebuhr* (Yale University Press, 1986), p. 54.
363 Chapter 3, Peter L. Berger, *A Rumor of Angels* (Anchor, 1970), pp. 69–70.

armor wearing a broken helmet with a makeshift visor, sitting astride a bony hack, spearing sheep on a Spanish hillside—convinced that they are a hostile army.

What madness! Quixote's misadventures are legendary—attacking windmills because he's certain they are giants with whirling arms; liberating a chain-gang after hearing the prisoners' biased accounts of why they were being held captive; whacking off the heads of puppets because he perceives the evil ones will triumph over the good; facing down a circus lion (which yawns and retires to its cage), then afterwards requiring of the attendant an affidavit to attest to his heroism.

The madman's delusions lead to a whole circle of co-dependants. Friends are forced into fanciful ruses to bring their patient home. In one attempt at recovery, Quixote's curate and barber pretend they are taking him to the realm of Princess Micomicona. In another episode neighbor Samson Carrasco appears in full regalia to do battle as if he, too, were a knight errant.[364] What lengths his companions will go to to cure the romantic's overheated sense of chivalry. Yet it is just Quixote's "devotion to nonsense, enthusiasm about trifles," deems essayist William Hazlitt, which make his experiences such powerful moral fables, for they portray a malady all of us are prone to.[365]

Yes, to a greater or lesser extent, we all belong to Hypocrites Anonymous. Laughter helps us to preserve sanity in a crazed world, provides the lubrication we so desperately need to deal with irritating people and situations.[366] Furthermore, it accents our need for humility by pricking the balloons of vain pretension. In life no doubt we will become the butt of many jokes we richly deserve; as Quixote's sidekick, Sancho Panza, once acknowledged, "Master, I confess that all I need to be a complete ass is a tail."[367] Laughter then becomes, in the words of Niebuhr, "a vestibule to the temple of confession."[368]

"Give us a sense of humor, Lord, and also things to laugh about. Give us the grace to take a joke against ourselves, and to see the funny side of the things we do. Save us from annoyance, bad temper, resentfulness against our friends. Help us to laugh even in the face of trouble."—A. G. Bullivant[369]

364 Chapter 14, Erich Auerbach, *Mimesis*, translated by Willard R. Trask (Princeton University Press, 1973), p. 351.

365 William Hazlitt, "On Wit and Humor," *Literary Criticism: Pope to Croce*, edited by Gay Wilson Allen and Harry Haydn Clark (Wayne State University, 1962), p. 266.

366 Brown, *Essential Niebuhr*, p. 51.

367 Book 2, chapter 28, Miguel de Cervantes Saavedra, *Don Quixote*, translated by J. M. Cohen (Penguin, 1970), p. 655.

368 Brown, *Essential Niebuhr*, p. 55.

369 "Prayers for . . ." Michael Hollings and Etta Gullick, compilers, *The One Who Listens* (Mayhew-McCrimmon, 1974), p. 60.

What Are a Few of Your "Favorite Things"?

1 Corinthians 12:4–12; Ephesians 4:4–13 "Take My Life, and Let It Be" by Frances Ridley Havergal or "'Tis the Gift to Be Simple" (Shaker song)

"Raindrops on roses and whiskers on kittens,

Bright copper kettles and warm woolen mittens. . . .

These are a few of my favorite things."—Maria Rainer in "The Sound of Music"[370]

In that same tune Maria goes on to list "cream-colored ponies," "crisp apple strudels," "doorbells," "sleighbells". . . . Indeed, whenever she's sad, recalling these delightful items helps to lift her spirits. Throughout the play it is Maria's exuberance and gift for music which enlivens the entire von Trapp household.

Sei Shonagan was a lady-in-waiting to Empress Sadako in tenth-century Japan. Each evening, when she retired to her room, she jotted down whatever pleased or

370 Act 1, Scene 3, Richard Rodgers and Oscar Hammerstein II, *The Sound of Music* (Bantam, 1967), p. 13.

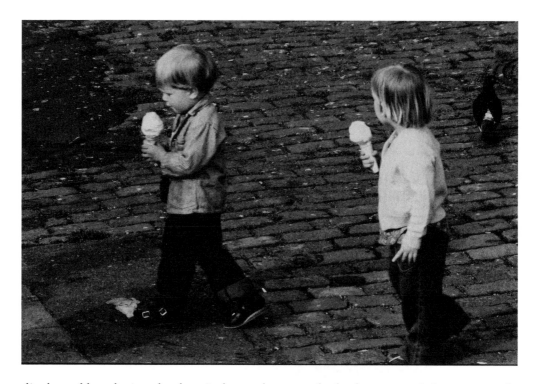

displeased her during the day. A sharp observer, she had strong opinions on nearly everything. One of her pillow book's most striking features is its 164 lists. Here's a sample entry: "Elegant things. A white coat worn over a violet waistcoat. Duck eggs. Shaved ice mixed with liana syrup and put in a new silver bowl. A rosary of rock crystal. Wisteria blossoms. Plum blossoms covered with snow. A pretty child eating strawberries."[371]

Elsewhere she enumerates "Rare Things," "Things that Makes One's Heart Beat Faster," "Annoying Things," "Things Worth Seeing," "Splendid Things," "Embarrassing Things," "Things that Have Lost Their Power," and "Things that Arouse a Fond Memory of the Past." Like Sei Shonagan, I, too, like to draw up lists of what I'm enamored by—objects which reflect, miniature things, strolls at dusk, wisecracks and aphorisms, spiral staircases, red raspberries, tête-à-têtes with friends, autumn leaves, ice cream. . . .

Perceiving one's gifts is a prerequisite to one's usefulness. Montaigne warned that parents and teachers "often spend a lot of time and effort for nothing, training children for things in which they cannot get a foothold."[372] To avoid such needless frustration, ask yourself: Do I prefer working inside or out? Am I meticulous,

371 Section 29, Ivan Morris, translator and editor, *The Pillow Book of Sei Shonagon* (Penguin, 1981), p. 69.

372 Book 1, chapter 26, "Of the Education of Children," Donald M. Frame, translator, *The Complete Essays of Montaigne* (Stanford University Press, 1979), p. 109.

precise, or prone to abstractions and generalities? Am I more inclined toward the cerebral or the athletic? Would I rather be a member of a team or lead? Do I like to carry through on a project or desire to teach others? By carefully sorting through various characteristics about yourself, you may uncover a vocation, a hobby, or some previously overlooked bent. Of the *charismata* mentioned by the apostle Paul (Rom. 12:4–8), notice how many concern inspired speech (e.g., prophecy, teaching, exhortation).[373]

In the body of Christ interdependence, not self-reliance, is the norm. "I play only upon one single instrument," comments nineteenth-century Lutheran theologian Richard Rothe. "I do not pretend to be in any sense the orchestra itself."[374] And again, "God does not require that each individual shall have capacity for everything."[375] We need rather to lean on each other and to encourage one another's potential, and so accomplish God's complete will.

Sovereign Dispenser of all that is good, here are a few things I'm enthusiastic about _____ , _____ . How can I put them to use in furthering your kingdom? Let me discern those gifts I have. Excite me to faithfully execute the tasks and duties I'm equipped and qualified to perform, happily and humbly leaving the rest to others.

373 James D. G. Dunn, "Gifts of the Spirit," *The Westminster Dictionary of Christian Spirituality*, edited by Gordon S. Wakefield (Westminster, 1983), p. 173.

374 Section 1, Richard Rothe, *Still Hours*, translated by Jane T. Stoddart (Hodder & Stoughton, 1886), pp. 52–53.

375 Section 7, ibid., p. 254.

Recommended Resources

Prayer Anthologies

George Appleton, editor, *The Oxford Book of Prayer* (Oxford University Press, 1985).

Tony Castle, compiler, *The New Book of Christian Prayers* (Crossroad, 1986).

Michael Counsell, compiler, *2000 Years of Prayer* (Morehouse, 1999).

Horton Davies, editor, *The Communion of Saints: Prayers of the Famous* (Eerdmans, 1990).

A. Hamman, editor, *Early Christian Prayers*, translated by Walter Mitchell (Regnery, 1961).

Jared T. Kieling, compiler and editor, *The Gift of Prayer* (Continuum, 1995).

Dorothy M. Stewart, compiler, *The Westminster Collection of Christian Prayers* (WestminsterJohnKnox, 2002).

Robert Van de Weyer, compiler, *The HarperCollins Book of Prayers* (Harper-Collins, 1993).

Mark Water, compiler and editor, *The Encyclopedia of Prayer and Praise* (Hendrickson, 2004).

Words and Stories for Hymns

Ian Bradley, editor, *The Book of Hymns* (Overlook, 1989).

Ian Bradley, editor, *Penguin Book of Carols* (Penguin, 2000).

Hugh Keyte and Andrew Parrott, editors, *The New Oxford Book of Carols* (Oxford University Press, 1992).

Kenneth W. Osbeck, *101 Hymn Stories* (Family Christian Press, 1982).

Kenneth W. Osbeck, *101 More Hymn Stories* (Family Christian Press, 1985).

Marjorie Reeves and Jenyth Worsley, *Favourite Hymns: 2000 Years of Magnificat* (Continuum, 2001).

Erik Routley, *An English-Speaking Hymnal Guide*, edited and expanded by Peter W. Cutts (GIA Publications, 2005).

Erik Routley, *A Panorama of Christian Hymnody*, edited and expanded by Paul A. Richardson (GIA Publications, 2005).

George William Rutler, *Brightest and Best: Stories of Hymns* (Ignatius, 1998).

Resources on Spirituality

Keith Beasley-Topliffe, editor, *The Upper Room Dictionary of Christian Spiritual Formation* (Upper Room, 2003).

Louis Bouyer, et al., editors, *A History of Christian Spirituality*, 3 Volumes (Seabury, 1982).

Michael Downey, editor, *The New Dictionary of Catholic Spirituality* (Liturgical, 1993).

Cheslyn Jones, Geoffrey Wainwright, and Edward Yarnold, editors, *The Study of Spirituality* (Oxford University Press, 1986).

Frank N. Magill and Ian P. McGreal, editors, *Christian Spirituality: The Essential Guide* (Harper & Row, 1988).

Bernard McGinn, et al., editors, *Christian Spirituality*, 3 Volumes (Crossroad, 1985–1989).

Bernard McGinn, editor, *The Essential Writings of Christian Mysticism* (Modern Library, 2006).

Bernard McGinn, *The Presence of God*, volumes 1–5 (Crossroad, 1991–).

Alister E. McGrath, *Christian Spirituality: An Introduction* (Blackwell, 1999).

Gordon Mursell, editor, *The Story of Christian Spirituality* (Fortress, 2001).

Philip Sheldrake, editor, *The New Westminster Dictionary of Christian Spirituality* (WestminsterJohnKnox 2005).

John R. Tyson, editor, *Invitation to Christian Spirituality: An Ecumenical Anthology* (Oxford University Press, 1999).

Robert Van de Weyer, editor, *The Illustrated Book of Christian Literature* (Abingdon, 1998).

Gordon S. Wakefield, editor, *The Westminster Dictionary of Christian Spirituality* (Westminster, 1983).

Acknowledgments

I want to offer special thanks to my wife, Barbara, for her valuable support, considerable number of helpful recommendations, and patience in waiting for me to take all of these pictures. I'd also like to express gratitude to all pastors, teachers, friends, and authors who brought me into a richer understanding of God and the deep resources of the Christian tradition. One title I want to highlight, since I've come back to it time and again, is John Baillie's *A Diary of Readings* (Scribner's, 1955).

I should commend Robert Meier at Photo Marketing Labs in St. Paul for his superb darkroom work, both in developing my film and in making prints. His encouragement helped make this book possible. Too, it was the processing department at Rockbrook Camera in Omaha who put my negatives onto a CD.

Finally, my warm appreciation to Bruce and Benjamin Fingerhut at St. Augustine's Press for their willingness to take on such an unusual project and for their expert guidance in bringing it to completion. Also, to Wipf & Stock (www.wipfandstock.com) belongs credit for allowing me to reprint the preface of my earlier book, *Gospel Midrashim: Poems on the Life of Jesus* for the chapter entitled "Symbolic Acts."

Listing of Photos in Order

1. man with magnifying glass
2. woman's face half in shadows
3. man with pipe and dog
4. Chinatown celebration
5. walking shadows on sidewalk
6. silhouette of man with hat
7. bikini-clad woman on beach
8. bird perched on bird statue
9. bird flying from building
10. spilled milk near fire hydrant
11. man helping woman in wheelchair
12. I'm getting my act together poster and woman
13. door with lock
14. man on other side of closed door
15. woman and child before wall inscribed "scientist"
16. smokestack with sun behind
17. smokestacks in daytime
18. elderly woman in train window
19. man holding head near bullet glass
20. man and woman sleeping in subway
21. gravestone with finger pointing up: rest in heaven
22. two playing chess
23. policeman handing out ticket
24. Atlas in front of St. Patrick's Cathedral
25. woman kissing baby
26. sidewalk band conducted by passerby
27. girl on park bench
28. girl playing with stuffed lion
29. woman looking out window at Cloisters
30. stairway in mirror
31. stone stairway
32. boy manikins behind bars
33. mother nursing baby
34. construction workers in building
35. man near grindstone

36. tear in screen
37. woman leading child across the street
38. for the poor of the world box and candles
39. man looking at beach
40. power in prayer evangelist
41. people looking at gulls
42. men lying on sidewalk
43. homeless woman with newspaper
44. black man carrying white female manikin
45. woman's feet on steps
46. shadow of flower on rock
47. three elderly ladies together
48. gargoyle fountain
49. man walking through manhole smoke
50. feet walking in wavy lines
51. candles and reflection on wall
52. boys playing football seen through fence
53. shot of clouds through rectangular keyhole
54. cat near cat card
55. country church near road
56. female manikin in rainy window
57. man with mask heads
58. dead trees in swamp with sun shining through
59. black cat on pampers package
60. clown near cootie toy
61. leaf in ice
62. kids eating ice cream

Scripture Index

Name and Title Index